CREATIVE
Calligraphy

CREATIVE Calligraphy

THE ART OF BEAUTIFUL WRITING

MALCOLM COUCH

TODTRI

This book was designed and produced by Todtri Productions Limited
P.O. Box 572, New York, NY 10116-0572 FAX: (212) 279-1241

Printed and bound in Singapore

ISBN 1-880908-99-9

Author: Malcolm Couch

Publisher: Robert M. Tod
Designer and Art Director: Ron Pickless
Editor: Nicolas Wright
Typeset and DTP: Blanc Verso/UK

Contents

Calligraphy

Introduction

Most of us have, at some time, looked at our handwriting and realized that it falls very far short of what we could achieve. Handwriting is, in fact, the practice of calligraphy – putting together words in a language and a particular alphabet that will convey information to someone else.

Calligraphy evolved as a craft over the centuries partly because writing was necessary for official documents, and partly because there was, until the invention of printing, no other way of recording information or of conveying ideas and news to other people.

The word calligraphy comes from the Greek words *kallos*, meaning beauty, and *graphos*, meaning writing or, more exactly, drawing. In China and Japan the craft of calligraphy is far older than in the West, and it has reached the status of an art form equal to painting and poetry. In this book, however, we will be more concerned with the calligraphy that is based on the Roman alphabet.

You do not have to be a brilliant draughtsman or artist in order to practise calligraphy. A degree of artistic skill is an advantage but is by no means essential. It is far more important to have an understanding of, and a sympathy for, the language of words and letterforms. Do not be discouraged if your first attempts do not match your expectations because a tremendous amount of satisfaction and enjoyment can be had from producing even the simplest calligraphic design.

What you will certainly need is a lot of concentration and a great deal of patience.

The main aim of this book is to introduce you to the fascinating and challenging craft of calligraphy. The following chapters will explain how best to start, what basic materials and equipment you will require, and how to construct the simple letterforms that will be the basis for all other styles of writing. With each of the main calligraphic alphabets illustrated there will be examples of the use of that particular style of writing in either traditional manuscripts or more modern work. Throughout the book you will find examples of the work of other scribes. These are included simply to give you guidance and to inspire you.

By the time you have worked through to the end of the book you should have gained enough confidence to design and produce your own calligraphy work.

Various forms of writing had existed long before the Greeks adapted the

Opposite page:
White calligraphic ink on black cartridge using a modernised version of original Greek characters

AB
INITIO
from
the beginning

AZHOIKΔ
ΓMΛNO
ΞΤΦΞ
PXY
Ψ

Phoenician alphabet to their own purposes, but it was the Greeks who first used the alphabet for decorative purposes. They had two main styles of writing. A carved letterform that was used for inscriptional work on monuments, and a written form that can still be found on a few surviving documents.

The Romans modified and adapted the Greek alphabet, not only to suit their language but also to create a definitive style for all documents and manuscripts throughout the Empire. With the rise of Christianity, and the increasing need for the written word to be used all over the developing world, many differing styles and letterforms evolved over the next few hundred years.

Uncial became the main Roman book hand during the fifth century. It is a style of writing, in majuscule (capital) letter, with unjoined, rounded letters; from it the modern capital letters have evolved. During the fourth to eighth centuries the use of uncial spread throughout Christian establishments, and in Britain and Ireland a style known as insular script was used for the masterpieces of the *Lindisfarne Gospels* and the *Book of Kells*. In other parts of Europe differing styles developed based on uncial.

One major factor in the development of a more hand-written script, such as uncial, was the change from papyrus to vellum as the medium on which

Right:
Insular minuscule from an early English document.

Opposite page:
A page from the Luttrell Psalter of the mid-14th century. The actual text is done in *Textura presciscus*, a form of textura with square bases to the majority of the lower~case letters

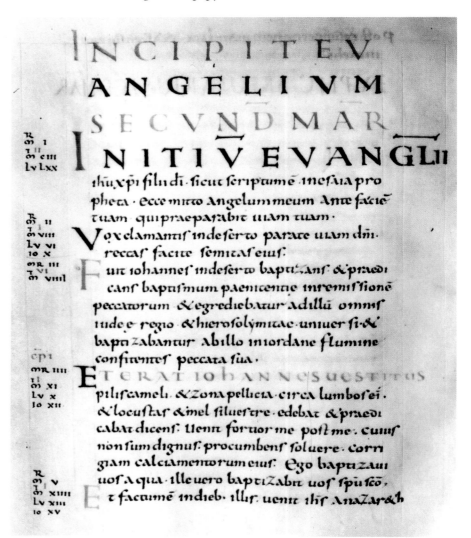

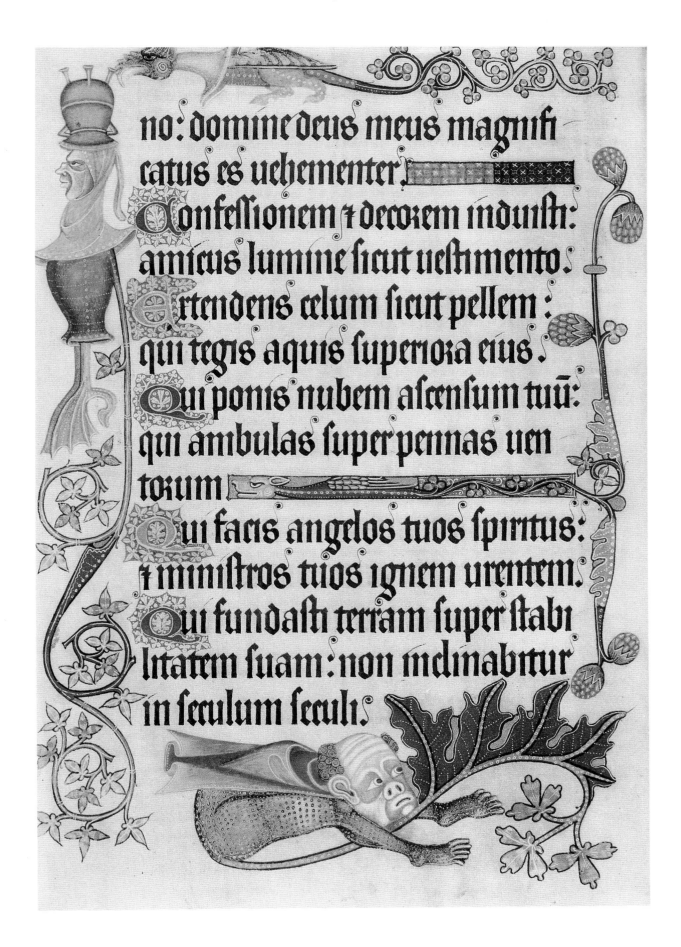

no: domine deus meus magnifi
catus es uehementer.
Confessionem ꝛ decorem induisti:
amictus lumine sicut uestimento.
Extendens celum sicut pellem :
qui tegis aquis superiora eius.
Qui ponis nubem ascensum tuū:
qui ambulas super pennas uen
torum
Qui facis angelos tuos spiritus:
ꝛ ministros tuos ignem urentem.
Qui fundasti terram super stabi
litatem suam: non inclinabitur
in seculum seculi.

Textura Quadrata Gothic text showing the 'textured' quality of continuous text.

Opposite page:
William Morris explored the possibilities of a 'modern' hand, based upon Caroline minuscules, during the late 19th century.

Following pages:
The Vespasian Psalter from Canterbury in the eight century, with uncial and half uncial text.

documents were written. Using sheets of vellum, it was now possible to form several written pages into a book form, known as a codex. Vellum could be folded far more easily than papyrus which could crack.

In the eighth century, at the instigation of Emperor Charlemagne (d.814), a standard book hand was created for all formal documents. Based on a variety of previous letterforms this new hand is referred to as Carolingian (or Carlovingian or Caroline) minuscules. It was the use of minuscules (lower case letters) in Carolingian text that marks the first use of capitals and lower case characters together.

In addition to the widespread use of this new hand, other styles were also developing. Gothic black letter was a very compressed and angular style, particularly suited to manuscripts where a lot of text had to be fitted into a relatively small space. This style was popular in northern Europe and was somewhat frowned upon by scribes in southern Europe. They dismissed it as being the writing of the barbarian, which is probably how the term for this style of text originated – Gothic, after the Goths.

In Italy in the fifteenth century there was a move towards a more swiftly written hand and one that would be suitable for the new age of science and scholarship. An angular, free-flowing hand, based on Carolingian minuscules, was designed. It was known as italic.

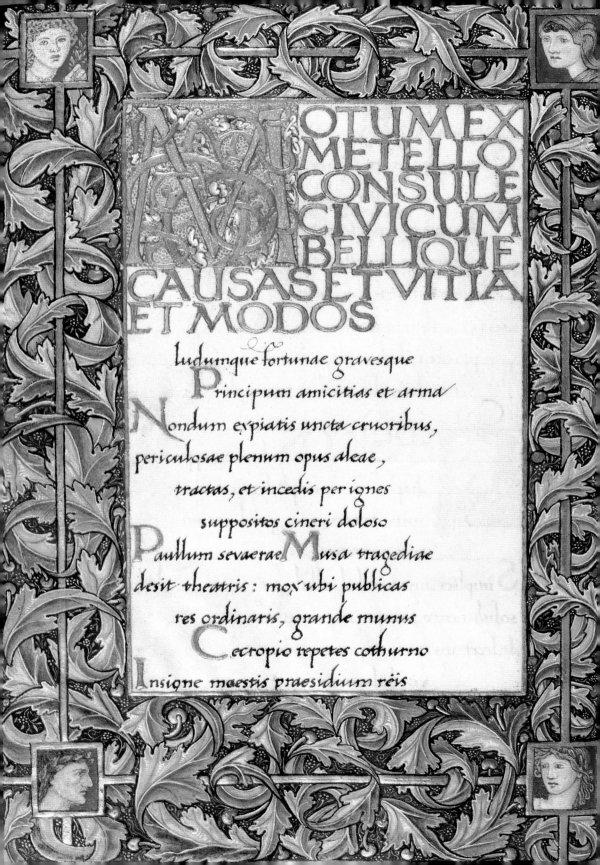

MOTUM EX
METELLO
CONSULE
CIVICUM
BELLIQUE
CAUSAS ET VITIA
ET MODOS

ludumque fortunae gravesque
Principum amicitias et arma
Nondum expiatis uncta cruoribus,
periculosae plenum opus aleae,
tractas, et incedis per ignes
suppositos cineri doloso
Paullum sevaerae Musa tragediae
desit theatris: mox ubi publicas
res ordinaris, grande munus
Cecropio repetes cothurno
Insigne maestis praesidium reis

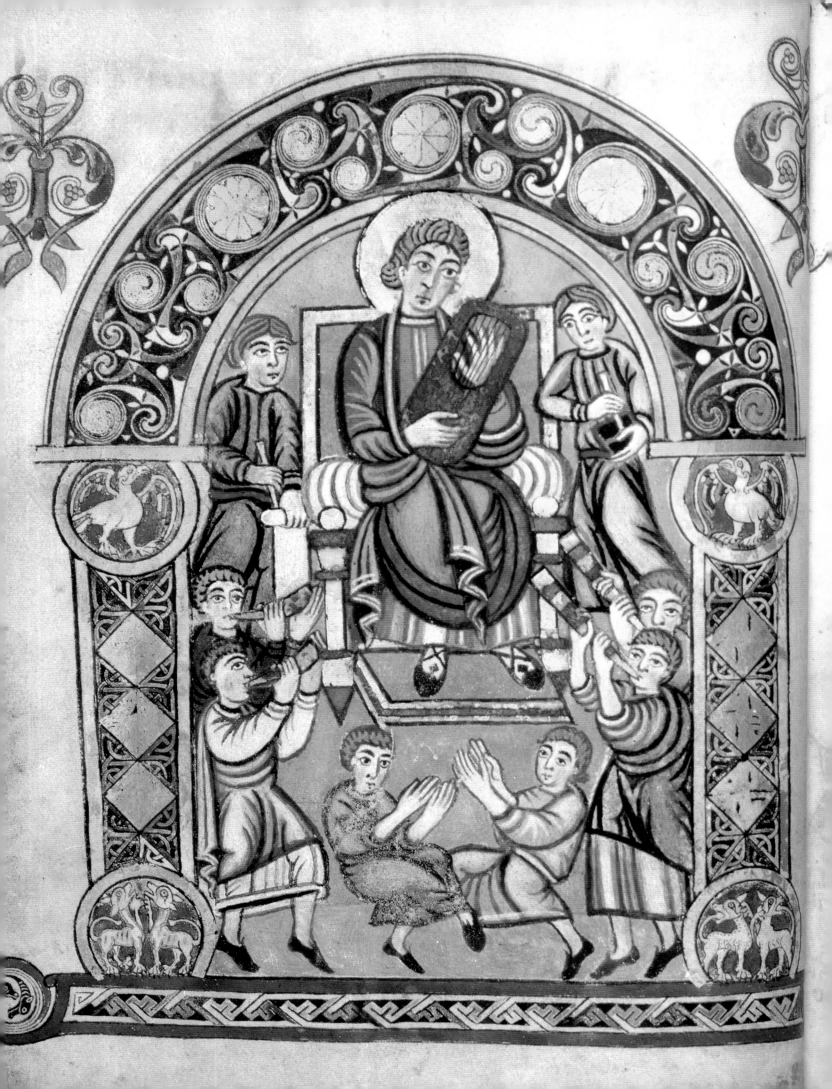

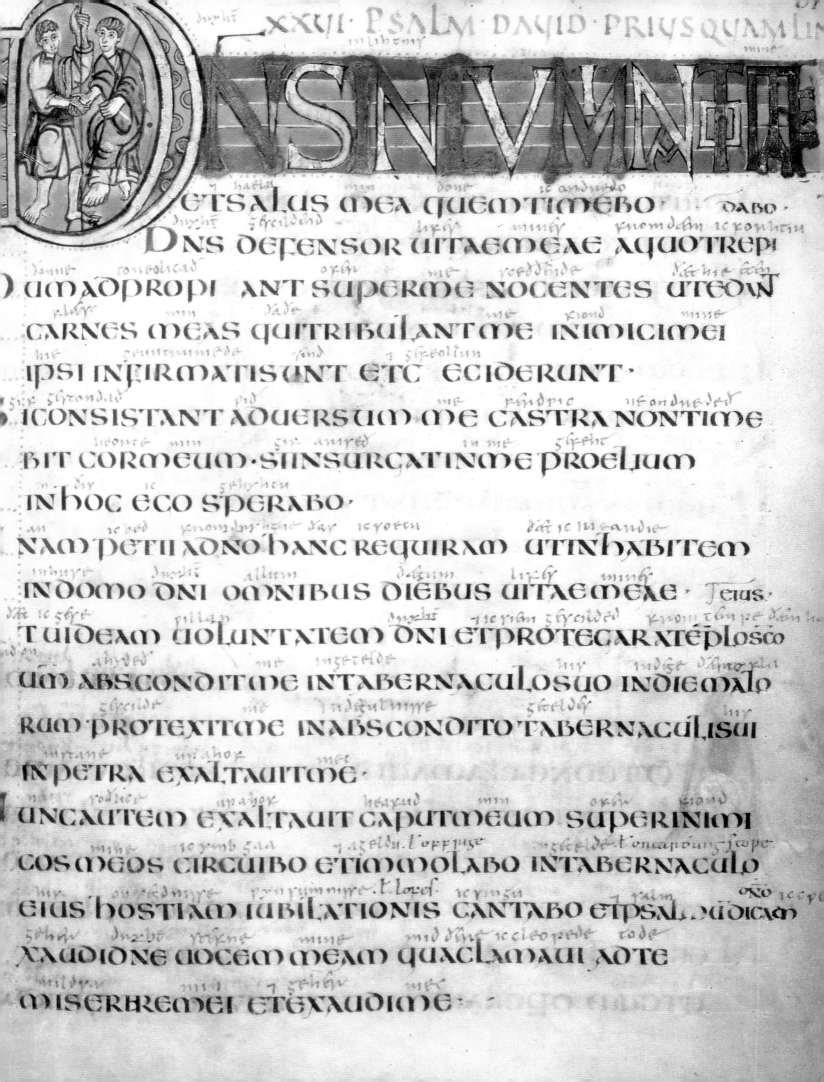

DNS NVMINATI

ET SALVS MEA QVEM TIMEBO

DNS DEFENSOR VITAE MEAE A QVO TREPI

DVM ADPROPI ANT SVPER ME NOCENTES VT EDANT

CARNES MEAS QVI TRIBVLANT ME INIMICI MEI

IPSI INFIRMATI SVNT ET CECIDERVNT ·

SI CONSISTANT ADVERSVM ME CASTRA NON TIME

BIT COR MEVM · SI INSVRGAT IN ME PROELIVM

IN HOC EGO SPERABO ·

NAM PETII A DNO HANC REQVIRAM VT INHABITEM

IN DOMO DNI OMNIBVS DIEBVS VITAE MEAE · ·

T VIDEAM VOLVNTATEM DNI ET PROTEGAR A TEPLO SCO

VM ABSCONDIT ME IN TABERNACVLO SVO IN DIE MALO

RVM PROTEXIT ME IN ABSCONDITO TABERNACVLI SVI

IN PETRA EXALTAVIT ME ·

NVNC AVTEM EXALTAVIT CAPVT MEVM SVPER INIMI

COS MEOS CIRCVIBO ET IMMOLABO IN TABERNACVLO

EIVS HOSTIAM IVBILATIONIS CANTABO ET PSAL. DICAM

XAVDI DNE VOCEM MEAM QVA CLAMAVI AD TE

MISERERE MEI ET EXAVDI ME ·

A poster for the London Sufi Centre.
(Ewan Clayton)

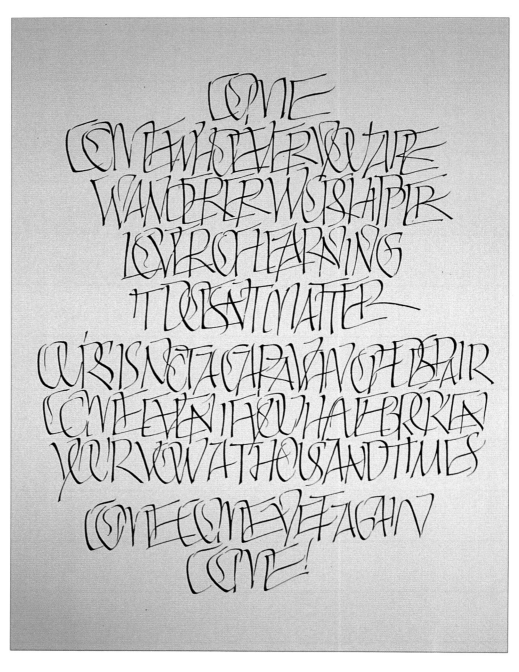

Opposite page:
An example page of copperplate
script from *The Universal Penman* by
George Bickham

Following pages:
Caroline minuscule text from the Grandval Bible

By the beginning of the sixteenth century a great deal of what had previously been written by hand was now being printed. Much of the everyday work was replaced by printing, and the amount of work that scribes could rely on was greatly reduced, but did not entirely disappear. Many of the existing letter styles were modified and redesigned to appear as typefaces.

Fortunately, however, the introduction of the printed word did not lead to the death of calligraphy. One consequence of the production of printed matter was that scribes created more elaborate styles of writing to attract their clients. This was particularly true in Italy, where a very florid, dramatic italic hand developed. This style virtually became the standard book hand throughout Europe over the next two hundred years, and it was used not only for official documents but also as the standard style of writing taught in schools and colleges. This lettering style became known as copperplate.

Specimens

Of the Running Hand, from the Performances of the best Masters,

By Geo. Bickham.

Aabbccddeefffgghbijkkllmnoppqr.rsfsttuvwnxxyyzz.&

Prize exquisite Workmanship, and be carefully diligent.

Its a brave Thing to equalize Works excellently perform'd

Aaabbccddeefffgghbijkkllmnooppqgrursfstttuvwnxxyyyzz.&

A A B B C C D D E F F G G H I J K K L L M M

N N O O P P P Q Q R R S S T T U V V W W X X Y Y Z Z

As a legible and free Running hand is indispensibly Necessary in all Manner of Business, I thought proper to introduce these Examples for the Practice of Youth, and their more speedy Improvement

September 4th, 1739.

G.B.

INCIPIT LIBER
EXODVS

AEC SUNT Cap.
NOMINA
FILIORŪ
ISRAHEL
QUI INGRES
SI SUNT IN ij
AEGYPTŪ
CUM IACOB
SINGULI
CUM DOMI
BUS SUIS
INTROIE
RUNT

Ruben. symeon. leui. iuda. issachar. zabulon
et beniamin. dan et nepthalim. gad et aser:
Erant igitur omnes animae eorum quae egres
sae sunt de femore iacob. septuaginta quinque
Joseph autem. in aegypto erat Quo mortuo et
uniuersis fratribus eius omniq; cognatione sua
filii isrt creuerunt. et quasi germinantes multi
plicati sunt ac roborati nimis impleuerunt terra
Surrexit interea rex nouus super aegyptum

puerorſ ſeruarear. Quae reſponderunt Non
ſunt hebraeae ſicut aegyptiae mulieres. Ipſe enim
obſtetricandi habent ſcientiam. Priuſquam ue
niamuſ adeaſ pariunt. Bene ergo fecit dſ obſte
tricib: et creuit populuſ. Confor
tatuſq; e nimiſ. Et quia timuerant obſtetriceſ
dm. aedificauit illiſ domoſ. Praecepit ergo pha
rao. omni populo ſuo dicenſ. Quicquid maſculini
ſexuſ natum fuerit. in flumine proicite. Quicquid
femineı reſeruate

E greſſuſ e poſthaec uir dedomo leui. accepta uxo Cap
re ſtirpiſ ſuae. quae concepit et peperit filium.
Et uidenſ eum elegantem abſconditorib: menſib:
Cumq; iam celare nonpoſſet. ſumpſit fiſcellã
ſcirpeam. et liniuit eam bitumine acpice poſuitq;
intuſ infantulum et expoſuit eum in careto ripae
fluminiſ ſtante procul ſorore eiuſ. et conſiderante
euentum rei Ecce autem deſcendebat filia pha
raoniſ ut lauaretur in flumine. et puellae eiuſ
gradiebantur per crepidinem aluei Quae cum
uidiſſet fiſcellam in paprione. miſit unam e fa
muliſ ſuiſ. Et allatam aperienſ. cernenſq; in ea
paruulum uagientem. miſerta eiuſ ait De infan
tib: hebraeorum e hic. Cuiſ oror pueri. Uiſin
quit ut uadam et uocem tibi hebraeam mulierem
quae nutriri poſſit infantulum. Reſpondit
Uade. Perrexit puella et uocauit matrem eiuſ

WILLIAM SHAKESPEARE

All the world's a stage,
And all the men and women merely players;
They have their exits and their entrances;
And one man in his time plays many parts,
His acts being seven ages. At first the infant,
Mewling and puking in the nurse's arms.
And then the whining school-boy, with

HIS SATCHEL, & SHINING MORNING FACE creeping like

snail Unwillingly to school.

AND THEN THE LOVER SIGHING

like furnace, with a woeful ballad
Made to his mistress' eyebrow.
Then a soldier, Full of strange oaths,
and bearded like a pard,
Jealous in honour, sudden and
quick in quarrel. seeking the
bubble reputation

Even in the cannon's mouth.
And then the justice, in fair round belly
with good capon lin'd, With eyes severe,
and beard of formal cut,
Full of wise saws and modern instances;
And so he plays his part,

THE SIXTH AGE

Shifts Into the lean and slipper'd
pantaloon, with spectacles on
nose and pouch on side,
His youthful

hose well sav'd, a world too wide For his
shrunk shank; and his big manly voice
Turning again toward childish treble, pipes & whistles in his sound.

LAST SCENE OF ALL

That ends this strange eventful history,
Is second childishness and mere oblivion
sans teeth, sans eyes, sans taste, sans everything.

15

Calligraphy

By the end of the nineteenth century the vast majority of text and information was being produced by the printing press. But a revival in the "lost" art of calligraphy and writing took place.

William Morris (1834–96) did not have a great deal of time for the development of industrialization, and he was in the forefront of the Arts & Crafts movement in Britain, and a movement with an interest in returning to the crafts and work of pre-Renaissance workmanship developed.

One of the students of this movement was Edward Johnston (1872–1944). Johnston became the father of modern calligraphy. From his work and his studies of traditional calligraphy, he designed a new "foundational hand" for lettering students. This was based on a tenth-century form of uncial writing. Johnston's works, and the influence they had on his students, was so great that we owe him an enormous debt for the revival of interest in calligraphy today.

The actual study of writing is a fascinating subject. We accept much of the written word today without realizing the fascinating story that lies behind the development of the simplest form of an everyday letter. The actual production of a piece of calligraphy gives us just a small insight into a craft that has lasted for centuries. The identity of the majority of the scribes who have produced magnificently illuminated and beautiful works of art over the centuries is unknown to us. Nevertheless, even the simplest work produced still holds something of the actual character of the scribe within it, even though we will never know who they were and in what conditions they laboured to produce their works of art.

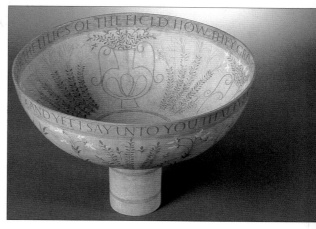

Above:
A beautiful use of calligraphy on a modern papier maché bowl (Hazel Dolby)

Facing page:
An experimental modern work by Lisa Scattergood with a mottled, tissue-dabbed effect

Very free-form script with small splashes of colour, from Melvin Stone

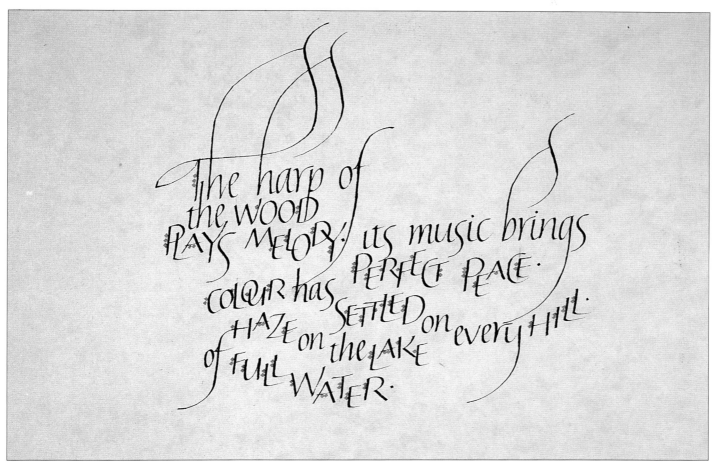

Part 1
Tools, Equipment
Paper & Inks

Tools & Equipment

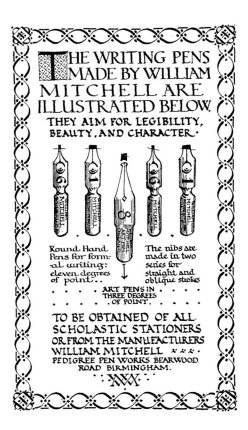

Early advertisement for pen nibs from William Mitchell

The range of tools available to today's calligrapher is extremely large, and this is part of the problem for the beginner. In one sense, all that you really need in order to start writing is a pen, some paper and some ink. Add to this a pencil, a ruler and an adjustable flat surface, such as a drawing board, and you can, in theory, go right ahead and start writing.

But this is to oversimplify the matter rather too much. Although it is true that it is unnecessary to buy a vast amount of equipment when you are just starting out, you do need to have some idea of the range and purpose of the basic items that you will require before you begin.

Until the introduction of the metal pen in the later years of the eighteenth century, scribes used the reed pen and the quill. The use of the reed pen is far older than the quill, and it is associated far more with the development of writing in the Middle East than in Europe. The quill is always associated with monastic scribes, Elizabethan writers and lowly clerks in Dickensian offices. Both reed pens and quills are still available today, but the majority of present-day calligraphic writing is produced using a metal pen, which has several advantages over both the quill and the reed. For one thing, metal pen nibs are more durable. The ink supply is more constant and can be controlled more easily, and there is a wide variety of nibs styles and widths from which to choose.

There are two main types of pen with metal nibs – the "dip" pen and the fountain pen. A dip pen consists of a pen holder, which will be made of either plastic or wood into which can be inserted a metal nib. Differing widths and styles of nib are interchangeable. A metal reservoir is clipped to the nib to provide a steady supply of ink. The only disadvantage, and it is a small one, of this arrangement is that it requires a constant refilling of the ink reservoir with either a brush or a pipette loaded with ink. The action of having to stop your work to refill the reservoir can lead to a break in concentration and interrupt the writing flow. It can also be a rather messier system than the alternative of a fountain pen with a built-in reservoir.

Fountain pens were originally developed to supply a near-constant supply of ink for hand-writing purposes. Several manufacturers now produce a range of fountain pens designed for calligraphic work, very often as an extension to their range of ordinary writing pens. The pens come with a set of interchangeable nibs. For calligraphy work you should make sure, however, that the fountain pen has a refillable reservoir, rather than one that takes

a replaceable cartridge. With the refillable reservoir you will be able to change the colour of ink far more easily than if your pen relies on cartridge refills.

The "calligraphic" fountain pen is ideal for the beginner. The range of available nib widths, however, is not as extensive as the range for the dip pen. Nevertheless, it will usually be quite sufficient to start with. The widest fountain pen nib is never as wide as the upper range of round-hand nibs. Nibs generally come in small, medium and large sizes, square-cut and italic, with a fine nib that is suitable for drawing or for adding flourishes. It is a good idea to start off using a calligraphic fountain pen and then, when you have gained more confidence and experience, move on to a pen holder with a range of nibs.

The very first pen that you buy, whether it is a fountain pen or a dip pen, may not be the ideal pen for either your particular style or method of

The workings of the reservoir attachment for metal nibs

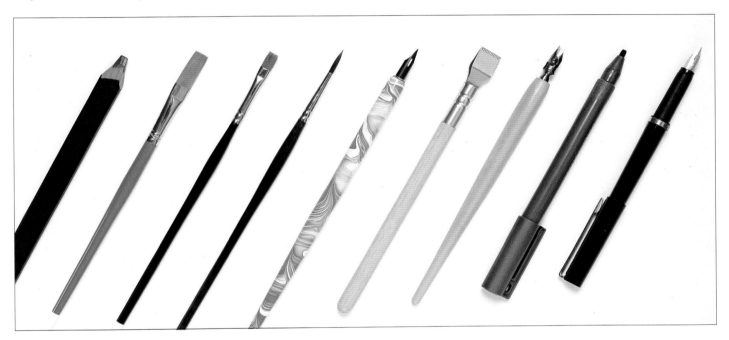

working. Always try to get as much advice as possible regarding the equipment you buy and be prepared to change if you do not feel comfortable with a particular item.

Left to right:
Calligraphy fountain pen; chisel-cut fibre pen; metal-nibbed dip pen; spring loaded dip pen; drawing pen; fine sable brush; chisel-edged sable brush; synthetic chisel brush; carpenter's pencil.

Metal Nibs

The present range of interchangeable nibs is very wide, and even a little daunting for the beginner. However, metal nibs are divided into certain, very definite "families".

● **Round-hand** nibs are the most widely available type that you will find in suppliers shops. They range in size from 0, the broadest, to 6, the narrowest, with 1/2 sizes numbered throughout. Nibs can be either square-cut or oblique. Reservoirs for round-hand pen nibs are sold separately, but they are of a common size and will fit all nibs throughout the range. You should use the reservoir attachment at all times unless your pen holder has a built-in reservoir. A separate reservoir is a much better alternative, however, because

you can more easily control the flow of ink.

● **Poster pen** nibs are much larger than round-hand nibs and are, in one sense, an extension of the range of widths available in the round-hand nibs. The broadest pen nib is about $^{1}/_{2}$ in (12mm) wide.

● **Script** pen nibs have a rounded tip that gives a very plain line of even thickness with none of the thick and thin variety of line that you get with the square-cut nib. These are often used for more informal writing, particularly on posters.

● **Copperplate** nibs are made specifically for copperplate writing, and they have a curious elbow-shape, which makes them look rather unwieldy at first. An ordinary drawing pen nib works quite as well, however, and will probably be a little easier to use at first.

● **Italic** nibs come in a wide range of sizes. They are cut straight across for right-handed work and at an oblique angle for left-handed writers.

● **Scroll** pens have a double-pointed nib suitable for decorative work and, as the name suggests, scroll lettering. On some nibs the two points are of varying thickness to give a thick and thin style to the lettering.

There are other nibs available, but those described above will be quite sufficient for an introduction to calligraphy.

Fibre-tip and Felt-tip Pens

Fibre-tip pens are chisel-cut and come in a range of widths, such as fine, medium and broad. They are fairly durable and are ideal for roughing out new ideas and for practising pen strokes and styles.

Felt-tip pens are not recommended for finished calligraphy work but, like fibre-tipped pens, they are very good for practising and for trying out new layouts. They have a limited life and become very ragged after a time. The ink in felt-tips can spread alarmingly on some paper surfaces because of the particular solution that is used in the pen.

Reed Pens

The reed pen is the earliest recognizable writing tool, similar to today's calligraphic pen, that carried ink or a pigment of some kind. Reed pens are available today, but they are rather difficult to get hold of. It is, however, always possible to make your own.

For this you will need a garden cane or length of bamboo. Better still, try to get hold of a suitable reed or cane from the riverbank. Clean off any

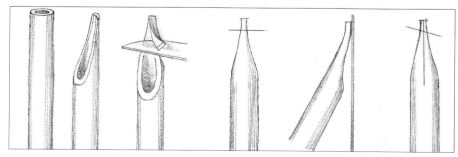

The procedure for making a reed pen, see main text.

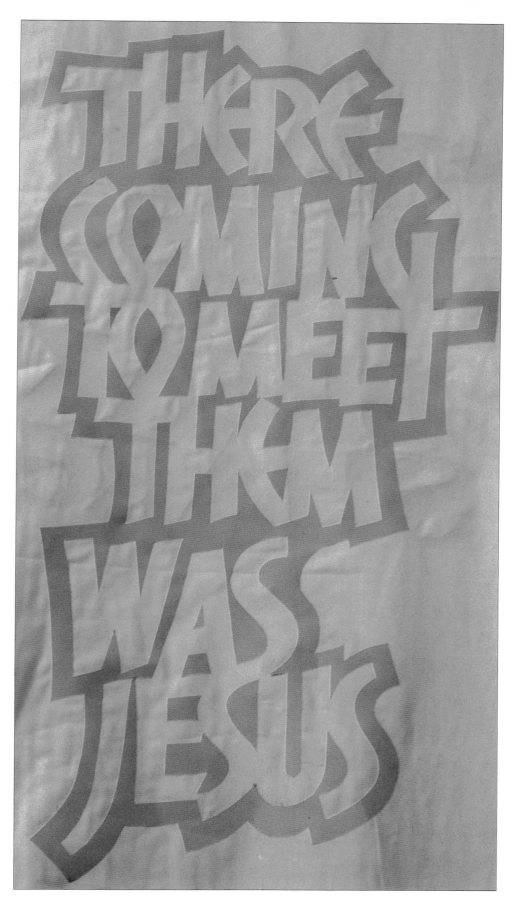

Block lettering on banners for Worth Abbey. Written on cover paper and then cut out to reveal yellow cotton background.
(Ewan Clayton)

excess bark from the reed and then cut off a section about 9in (23cm) long. Clean out the pithy inside of the reed and then make an angled cut across the reed. Pare away both sides of the reed to form a nib shape. Turn the reed over so that the back is uppermost and cut the nib at right angles to the shaft of the reed. A short, vertical cut must now be made in the nib end. To do this you can either lay the nib down on a flat surface or make the cut with the reed held in the hand. The cut slit can be lengthened by carefully pressing the nib area upwards. The finished slit needs to be about $^3/_4$ in (20mm) long. Finally, lay the nib on a flat surface and cut across the end at an angle of about 70 degrees. This will get rid of the first cut that you made into the nib area. In order to make the pen more practical and so that it can carry ink you can insert a clock spring or similar piece of sprung metal into the reed, but the reed can be used as a pen without this addition.

Quill Pens

It is possible to buy quills that are ready for you to use. As with the reed pen, however, it is also possible to make your own quill pen.

It is something of a misconception – and self-indulgence on the part of film-makers and illustrators – to show a scribe wielding a full-length, large-plumed, feathered quill. If the quill were the length of the feather from

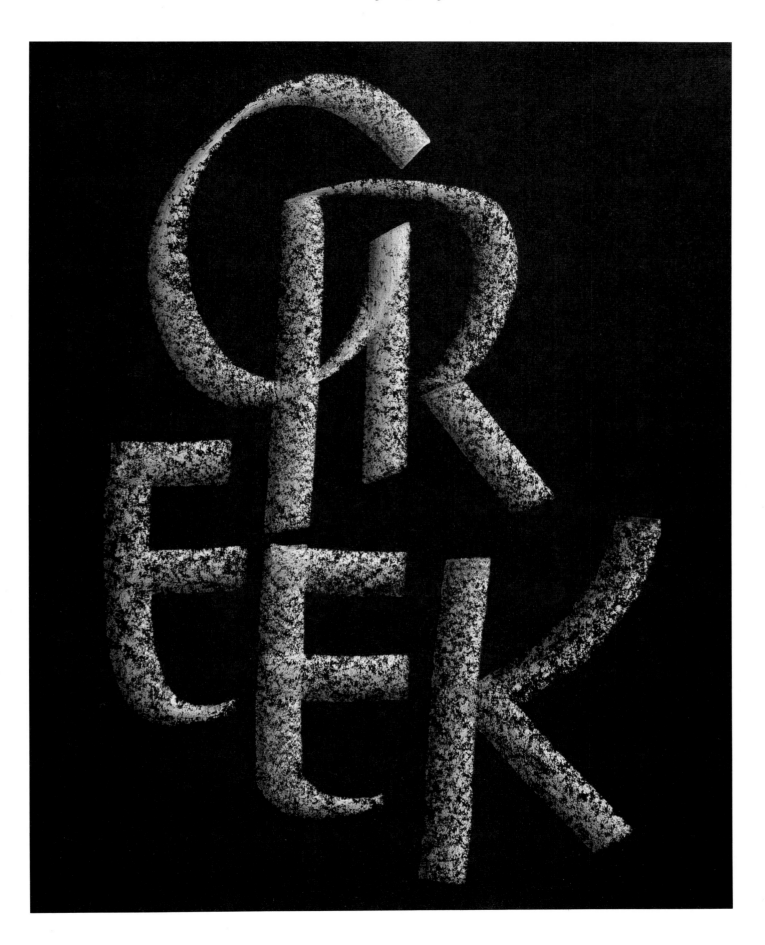

LITTLE

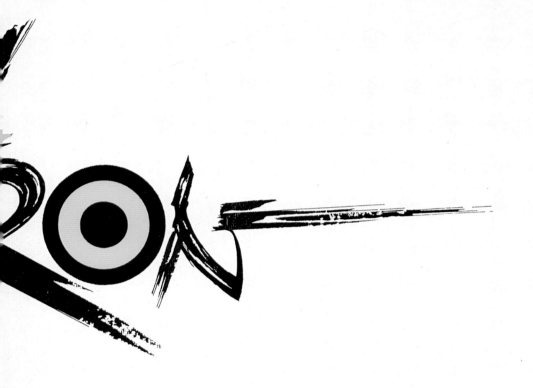

cormorant

OYSTERCATCHER

WILLIAM SHAKESPEARE

Above:
Three very different examples of calligraphic lettering. The top two being part of a series for British birds, and the lower example is taken from the poster on page 18. (Lisa Scattergood)

Previous pages:
Grey Heron from a series of calligraphic interpretations of British birds. (Lisa Scattergood)

which it was taken, it would be very inconvenient for the scribe to use, because it might easily knock against the face, upper arm or anything else that happened to be in the way.

If you want to make your own quill pen, cut the feather down so that it is about 9in (23cm) long. Strip off the feathers from both sides of the shaft. A small slit must then be made in the end of the quill (see the description of the reed pen above).

The stiffer the quill is, the longer this slit must be, but with most pens it will be about $\frac{1}{2}$in (12mm) long. Trim the end of the nib to the required shape, then lay the nib on a flat surface with the back of the quill uppermost. Make a cut at an oblique angle across the end (about 70 degrees) and also at a slight downwards angle so that the end of the nib is sloping. The width of the pen nib, after it is cut, should be the width of the thickest stroke of the letter that you are planning to make.

You should now have a quill with a nib that is suitable for writing. A reservoir can be inserted in the same way as for a reed pen. The nibs of quill pens need to be re-cut and reshaped quite often, but the actual process of writing with a quill or reed pen has a certain romance and tradition about it that cannot be equalled by the use of more modern instruments.

Brushes

A couple of round-hair sable brushes are essential for loading pens with ink and for the occasional fine lines that you might want to add to serifs and flourishes. You should also have a broad chisel-edged brush. This is ideal for calligraphy work and can often take the place of the metal pen. It is particularly suitable (even necessary) if you want to recreate Imperial Roman capitals, because only a chisel-edged brush can replicate the subtlety of the serifs on these capitals.

A flat chisel-edged sable brush is the best you can buy, but they are expensive, and to begin with you may want to use one of the many synthetic haired brushes that are available and that are quite adequate for the task.

You will find it a great advantage to have a wider range of brushes, but this could prove rather expensive, and you will probably want to build up your range as you become more experienced and do more and more calligraphy. If you are planning to do much colour lettering you will need several brushes. If you only have a limited number of brushes each one will have to be cleaned, very thoroughly, each time you change to another colour of ink or paint. Ideally, you need a separate brush for each colour, although these do not necessarily have to be the expensive, top of the range brushes.

You will often see Chinese brushes for sale in art and craft shops. These are specially made for the original style of lettering intended, but they are great fun to use, particularly if you want to experiment with different letterforms. The method of working with them means that the brush is held in a much more upright position than that used for the metal pen.

Left-handed Calligraphers

Most instructional work for calligraphers tends to assume that the artist is right-handed. This has been the assumption for many years and was a direct cause of the need for ancient scribes to work from left to right.

Any slight disadvantage that left-handed calligraphers experience has been overcome now that many manufacturers of calligraphic equipment produce left-oblique nibs especially for left-handed writers. It is also possible for left-handed writers to use square-cut nibs.

The main difference between the two styles will be in the positioning of the paper in relation to the hand. In addition to saying that the position will be a mirror-image of that used by a right-handed person, the angle of the work sheet will be slightly different. Some left-handed writers have the paper at a very extreme angle – almost 90 degrees from the vertical on occasions. For people who place their paper in this way, a square-cut nib can be used. Other writers, with a less extreme angle of working, will find that the special oblique nibs for left-handers are suitable.

Try to avoid a hand position that is too "hooked", because this will cause your writing to be cramped – this applies to right-handers, too, of course.

Calligraphy

Paper

Y ou can, in theory, carry out your calligraphy on almost any paper or card you wish. Before deciding which surface you are going to work on and experimenting with the varieties of paper are available, however, it will be helpful to understand something of how paper is made. The first writing surfaces that took the mark of a reed pen or brush and that bore some similarity to present-day paper were animal skins and papyrus. For the Egyptians, Greeks and Romans papyrus was the main material used for writing. Animal skins were also used, but only for the most important documents.

The word "paper" is actually derived from the Latin word *papyrus*, which was, in turn, derived from the Greek word *papuros*. The Arabs learned the secret of making paper from the Chinese and introduced it into Europe at the very end of the Middle Ages. The first mill producing paper is thought to have been built in Italy around 1270.

Early rough workings for the finished lettering of 'cormorant' on page 30.

Facing page:
*Top to bottom.*300lb not; 140lb rough; 140lb not; 140lb hot pressed; tinted 140lb watercolour; 90lb cartridge.

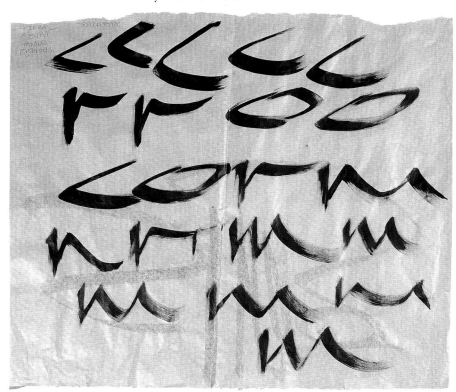

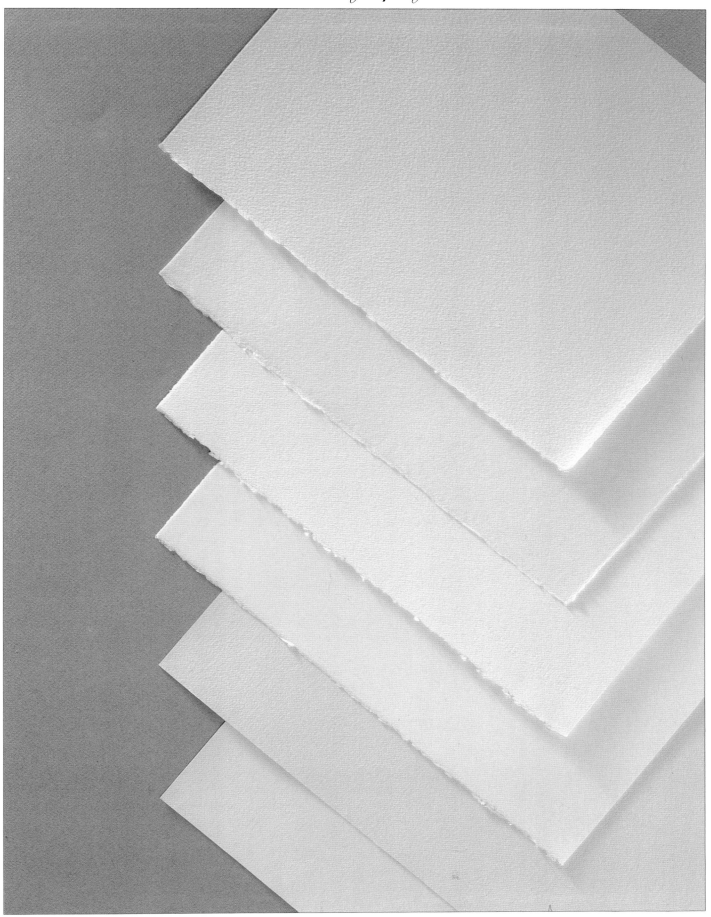

Until this time, and for many centuries afterwards, all documents were written on parchment or vellum, which replaced the use of papyrus.

The basic method for making paper has remained the same for centuries. Vegetable fibres or rags of cloth and linen are soaked in water and then dried out to form thin sheets.

Today, the majority of manufactured paper is machine-made. This comes off the machines in continuous rolls, which are then cut down to the appropriate sizes. Hand-made papers are also available, but as they are made in single sheets, without the use of mass-production methods, they are more expensive than machine-made varieties. They also tend to be heavier than machine-made paper, and the quality is far higher, particularly for calligraphy work.

Papers made from a wood pulp base are generally lower in grade and quality than those with a rag base. The finest quality papers are made from linen.

Although there are far fewer hand-made papers available these days, the range of machine-made papers is improving and increasing all the time.

When you are looking at different types of paper you will frequently come across descriptions such as "hot pressed" or "rough". These words refer to the type of finish that has been given to the paper.

- **Hot-pressed** paper, which is also known as HP, is fine-grained and the surface is quite smooth.
- **Not** paper is very often the same grade of paper as hot-pressed but it has not been rolled, or pressed, as heavily and has a slightly rougher surface.
- **Rough** paper has not been dried or passed through rollers but allowed to dry naturally. The surface is, therefore, rougher than Hot-pressed or Not.

Hot-pressed paper is an ideal surface for finished calligraphy. Both Rough and Not papers have slightly more absorbent surfaces. Rough is more suitable for brush lettering than for work with the pen.

Vellum is the traditional writing surface, and it has been used since before the introduction of paper in the late Middle Ages. The skin of a calf, or kid, goes through a lengthy and complicated process before it is suitable as a writing surface. It is, however, the finest of writing surfaces and is particularly suitable for the quill. Vellum is available today, but it is, naturally, expensive.

Parchment is quite different from vellum. It is made from the skin of either a sheep or a lamb, and it goes through a similarly lengthy process of preparation as vellum. The surface quality is not as good as vellum, but the advantage was that parchment could be made in thinner sheets than vellum, which meant that a manuscript containing several pages could be conveniently bound together. You can buy a "mock" parchment from some suppliers, but this is actually made from paper.

Always have a supply of layout or tracing paper handy. Layout paper has a slightly milky colour to it and is a little more opaque than tracing paper. Both papers come in pads in a range of a sizes or you can buy single sheets from art suppliers. Both papers are ideal for trying out rough ideas and letterforms.

A good, standard paper to use for practising pen strokes is ordinary typing or bond paper. This is available almost anywhere. It is a cheap, machine-made paper that comes in standard sizes, and it has a reasonable surface.

The next grade of paper for calligraphy work is cartridge. This can come in a variety of weights and qualities. Except for practice work, it is best to get the best quality cartridge paper you can. The lesser qualities are very good for pasting down work for reproduction.

The most suitable papers for calligraphy come with a variety of brand names. It is best to try out several different papers in order to find the one most suitable for you.

Paper Grain

If it is your intention to fold your calligraphy work – for a greetings card or small booklet, for example – you will have to consider the grain of the paper, which will have a significant effect on the finished work. Perhaps the easiest way to find out which way the grain runs is to tear the paper. The paper will tear more easily in the direction of the grain. Another method is to take the paper and loosely fold it over in one direction and then in the other direction. It is easier to fold in the direction of the grain.

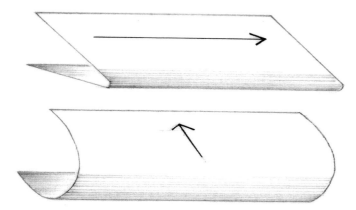

Left:
The direction of the grain in a sheet of paper is evident when the paper is lightly folded. The paper will fold more easily along the grain.

A tinted watercolour surface will cause pen work to break up more easily than a smoother cartridge, although brush work will give a more even distribution of ink on either surface.

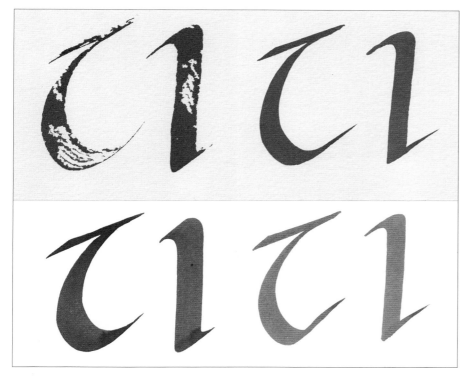

αγάπη

Love
 The network of islands
 And the prow of its foam
 And the gulls of its dreams
 On the lightest of its waves an island
 Cradles the arrival

Inks

Inks were originally made using lampblack (a pigment made from soot) mixed with gum and water according to preferred recipes. This produced a very dense black carbon ink, which was permanent. You will often see old manuscripts, however, that have an attractive brownish-sepia effect to the lettering. This comes from the chemical actions on the ink over the years, which have caused it to fade slightly. The colour is not because sepia ink was originally used.

The choice of writing and calligraphic inks today is quite wide, and inks can vary quite a lot from one manufacturer to another. It will probably be only by trial and error that you will find the out which inks will best meet your own needs and style.

When you are buying and using ink of any kind, one of the most important considerations is to make sure that it will not clog the pen. The ink must be free-flowing. It is, therefore, far better always to use a non-waterproof ink for calligraphy work. Waterproof ink clogs more easily and will not always produce a fine line on the paper. The only time when it will be necessary to use waterproof ink is if your work is going to be displayed outdoors, such as on a poster. Always make sure that you wipe the nib dry after using waterproof ink. Never use waterproof ink in a fountain pen.

The permanency of the ink is also an important consideration. Of course, this will only be proven over time, but if you want your work to last, it would be wise to check with the supplier regarding the ink's permanency. Inks that are not permanent will fade away in time.

The ideal ink for calligraphy, particularly when you are just starting out, is a non-waterproof, fairly permanent, free-flowing calligraphic ink for either a fountain pen or a dip pen.

The ink that is preferred by many practising calligraphers for finished, high-quality calligraphy work is Chinese stick ink. This, as its name suggests, comes in the form of a stick of prepared black ink, which has to be ground down and mixed with water (ideally distilled water) to make up a liquid black ink of the right consistency. This is usually done on a specially made rubbing stone. If you do use Chinese stick ink, the correct combinations of water and ink are so critical that it is always wise to note the proportions of each every time you make some ink. It is, consequently, a rather difficult task for the beginner, but it is worth trying. Like working with the reed pen or quill on vellum or parchment, using Chinese stick ink is all part of the tradition of calligraphy.

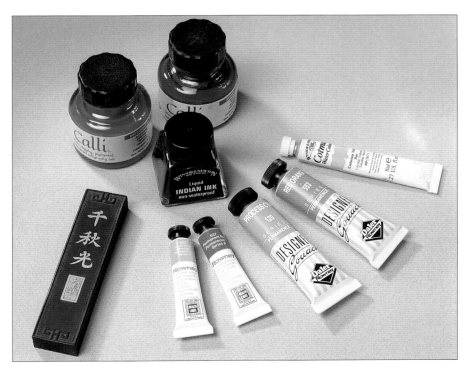

A good range of quality inks and paints is essential for serious calligraphic work.

Coloured Inks

A vast range of coloured inks is available, but in general, coloured drawing inks are not as easy to work with as may first seem to be the case. They frequently have dyes added to them that can have adverse effects on the writing surfaces. They are also not very permanent, and they can clog the pen quite easily. If you do decide to use coloured inks, it is advisable to stick to coloured writing inks, which have been specially prepared for this kind of work.

Sometimes, you may want to slightly alter the colour of the ink you are using, and this can be easily done simply by mixing one ink with another until you have the desired colour or shade. Check, therefore, if the inks within that range are miscible – capable of being mixed together without adverse effects. Once again, the ink should flow easily and not clog the pen.

Watercolour Paints

It is much more satisfactory to use watercolours than coloured inks, and it is infinitely easier to get a precise colour. Artist's watercolours and gouache (otherwise known as designer's colour) are very suitable for pen work and are readily available for art shops.

Artist's watercolours retain their vibrant colour value even when they are diluted. Gouache is also water-based paint, but it is more opaque than watercolour. It is particularly useful for adding areas of flat colour.

The consistency of the both paints can easily be altered by the addition of more water or more paint. It is always better and easier to begin with a dark colour and to lighten it with water, than to add paint to increase the strength of a colour.

When you buy either artist's watercolours or gouache you should try and get colours that are permanent. Although they may prove a little more expensive, the extra cost is really worthwhile.

Part 2

Penmanship
Layout
Basic Pen Strokes
Basic Letterforms

Penmanship

C alligraphic writing should never be forced. The ideal to aim for is an easy, rhythmic flow, with the pen skating lightly, but positively, across the surface of the paper. In order to achieve this ideal, however, there are several important things to consider even before putting pen to paper.

Writing Position

How and where you sit when you write is very important. You must, of course, have everything that you will need conveniently to hand and be sitting in a comfortable position.

Perhaps more important, however, if your posture. Although you are not preparing for any strenuous physical activity, it is essential that you have a comfortable working position. If you are not sitting correctly it will be very difficult to work efficiently, and you will, inevitably, begin to feel back or shoulder strain before too long.

First, your chair and table must be at the correct height. You should sit on a chair or stool that does not have arms. There is sure to come a time when

Setting up the work surface

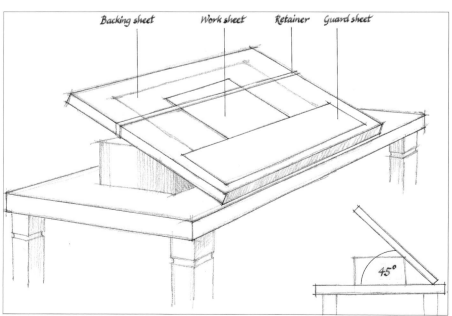

the arm of a chair will get in the way.

Second, if you are going to use a loose drawing board, as distinct from a fixed or angled drawing board mounted on your table, you should be able to rest the board against a support in such a way that it will not move when you begin to write.

Finally, when you are sitting in your chosen position, with the board angled in front of you, hold the pen in your normal writing position. Your arm should rest comfortably against your side. Place your hand easily on the drawing board as though you are about to start writing. This is the correct writing position for you. Now check whether you can detect anything that might prove uncomfortable after a time – remember that you might be sitting in this position for quite some time.

The surface on which you work should, ideally, be a drawing board, but precisely what this is actually made of can vary greatly. The ideal is a traditional wooden drawing board, but it is just as easy to work on an board made from an off-cut of plywood or any smooth board obtained from a local craft or do-it-yourself store. Medium density fibreboard (MDF) is particularly suitable. It is relatively inexpensive, it will not warp, and it can easily be cut to any required size.

When the drawing board is in the writing position, the angle between the board and the table should be about 45 degrees. You will also need to be able to arrange the board so that it is at a slightly lower angle if you intend to use paint or a broad nib.

The angle between the pen and the writing surface will vary slightly, depending on the particular style of lettering you will be doing. But, generally speaking, the pen should be held at about 60 degrees. If you hold it at a shallower angle the pen strokes will be less effective.

Positioning the Worksheet

Fix a sheet of card, blotting paper or even newspaper to the drawing surface. This will provide a more resilient surface than if you fixed your paper directly to the hard drawing surface.

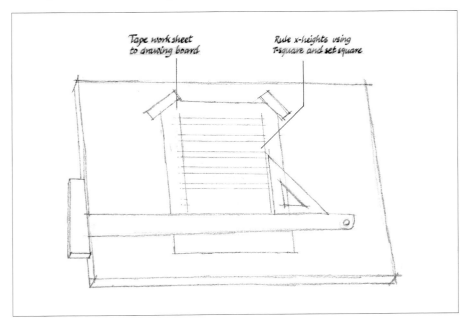

Tape work sheet to drawing board

Rule x-heights using T-square and set square

T-square and set-squares are very necessary when ruling up a work sheet

BORDERS

The paper on which you will be writing – the work sheet – should not be fixed to the board. You will need to move the work sheet upwards or sideways on the board in order to keep the line of lettering in the correct position for your pen. Always move the work sheet to where the pen is, rather than moving the pen (and your whole hand) to where the writing should appear.

Fix a sheet of scrap paper, such as good quality cartridge, over the lower part of the board. This sheet will not only take the pressure of your hand but it should also protect the work sheet from being marked.

Use a large rubber band or a length of tape to keep the work sheet in position while you are working on it.

Preparing the Worksheet

The first task is to rule up the lines for the lettering, and for this you will need to fix the work sheet to the board with a couple of pieces of masking tape.

Each of the calligraphy alphabets in this book has details of the correct depth for the x-height and the cap-height of the letters. These sizes will vary from one alphabet to another, and they are given in the number of pen widths required.

Once you have checked the measurements for the alphabet you are planning to use, take a strip of scrap paper, fill your pen with ink and make a mark of one pen width against the edge of the paper strip. Then repeat this mark for the number of times required for the x-height and the cap-height of that particular letter face. Then rule lines across from these marks on the scrap sheet for both the x-height and cap-height.

You can then use this paper guide to measure off, and mark, the lines on the work sheet. Alternatively, you can measure off the distances with a pair of dividers.

With a ruler, a set square and a sharp pencil, you can proceed to draw the lettering lines across the actual work sheet. Use a medium or soft pencil for this and make sure that you have positive straight lines. The best way to achieve this is to hold the pencil upright against the edge of the ruler when you are drawing the lines. Do not press too heavily on the paper with the pencil. It should be enough to make a mark, but not a groove. You are now ready to work.

This method of measuring off the x-height based on the nib width is particularly good as it means that you will preserve the overall proportions of the letterform.

Tips

- Take good care of all your equipment and clean it regularly and thoroughly.
- Shake the bottle of ink before using.
- All new nibs will have a lacquer coating on them. This must either be burned off by exposing it to a naked flame for a very short while or washed off and the nib dried thoroughly.
- Load ink on to the pen using either a loaded brush or a pipette; this is preferable to dipping the pen into the ink bottle.
- Always wipe the ink from the nib with a cloth or a piece of tissue paper

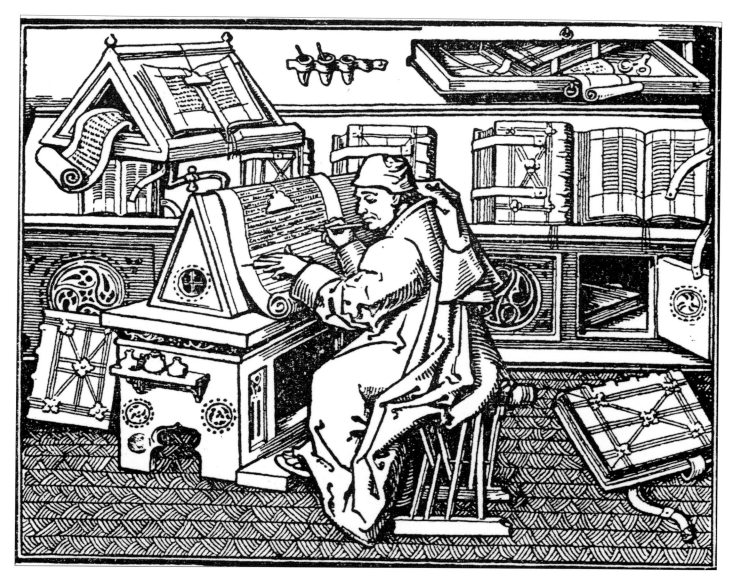

A medieval scribe poring over a manuscript.

after you have finished lettering.

● Immediately you have finished working, detach the reservoir, clean both the nib and reservoir and allow them to dry.

● Never leave the reservoir attached to the nib, unless you are certain of continuing work very soon after. Never leave the reservoir attached if it still has ink in it.

● Clean brushes in water, dry them and store them after use. It is best if you can keep them in an upright position, bristles uppermost.

● Try to keep a separate brush for each colour.

● Replace all tops of paint tubes and ink bottles when they are not in use.

● Paper should be stored on an absolutely flat surface, preferably away from dust and sunlight. The flat drawers of a plan chest are ideal for this. If you have to store paper by rolling it should be done without tension and loosely tied or banded.

● Knife blades, particularly sharp scalpel blades, should be protected by embedding them in a cork or an india rubber.

47

Layout

Whenever you plan a new piece of calligraphy there are a number of decisions that have to be made. These concern the actual wording, the layout and style of the lettering, the spacing and the overall "look" of the intended work. Always remember that it is far, far better to have a definite idea of what you want to achieve before you put pen to paper rather than to make it up as you go along. Time spent working out what you are going to do beforehand is never wasted.

It is also important that you begin to appreciate what good design is and what it looks like. We tend to recognize bad design more easily than we

Black and white calligraphy work for a Christmas card. This design was later foil blocked, see pages 120/121. (Ewan Clayton)

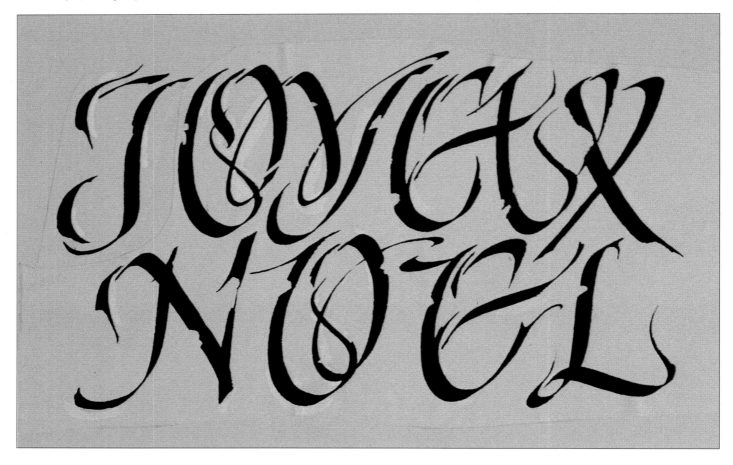

Mediaeval toys.

the battlefield.

Wooden soldiers with jointed limbs which could be manipulated by cords were favourite toys after the Norman conquest, and children also played with model soldiers on horse-back. Lead was used in the making of toy soldiers as early as the 13th century.

During the 14th century, dolls wearing the latest modes from Paris were circulated abroad as inanimate mannequins, and this practice continued right up to the

spot good design. Bad design often makes things difficult to read and frequently has an "uncomfortable" or clumsy feeling about the spacing or the style of lettering.

The majority of all calligraphy work is done to communicate an idea, a phrase or title, or a whole section of text. It is a visual interpretation of a set of words.

By really "looking" at other calligraphy work, even everyday notices, signs, magazines and newspapers, as well as taking every opportunity to study traditional manuscripts, you will be able to spot certain common features. All calligraphy work should be legible. The reader should be able to work out not only what it is saying but also the purpose or the message behind the lettering.

Once you have decided, therefore, on the actual words that you will place on the page, you must consider what style of writing will best suit the text. If, say, you want to copy out a favourite poem, there is a certain style that immediately springs to mind as being correct. For example, a traditional poem may look best if a traditional style of lettering, such as an uncial, is used, while a more modern poem might appear more attractive in an easy flowing italic form – a "conversational" hand. The choice is largely up to you.

The next consideration must be how the lettering will appear on the page. What space will it occupy? Should it be formally centred within the space or should the lines be staggered and arranged at random?

It is a very good idea at this stage to familiarize yourself with the text by writing it out a few times in rough form. If you remain undecided on a letter style, you can then try it again in an alternative alphabet. If you work in

A page from a thesis on toys produced as a students thesis using a simple Foundation hand and a fine sense of proportion.
(Anne Brightmore-Armour)

Pasting up the rough version of the calligraphy work by centering each of lines of text on a common centre line.

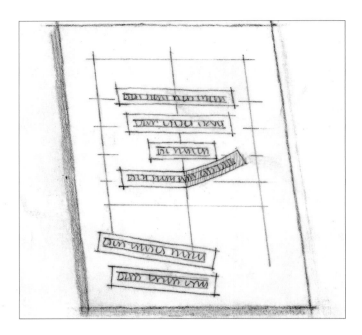

pencil or fibre-tip pen on layout or tracing paper, you can cut up the individual lines and re-arrange them on the page to find the best disposition. This will give you a chance to look at the layout, size and letter style more critically.

You can now see whether the work could be improved by embellishing some of the letters, perhaps with illumination or just by enlarging initial letters. Would certain words look better in bolder lettering in order to emphasize certain parts of the text? Or will the work stand alone with a formal arrangement and letter style that will allow the words to just "speak for themselves"?

Spacing

Whenever one letter is placed next to another the space between those two letters will determine the spacing for the rest of the line of lettering and, possibly, the whole work.

There is no mathematical formula that can be applied to determine the spacing between letters. But there are certain guidelines that you can follow.

Two curved letters can be spaced fairly closely together. When a curved letter is next to the vertical stroke of a letter there should be a medium amount of space. Two upright strokes together should have the greatest space between them. This is not a rigid rule and it can be affected by the actual letter style being used, but it is a good starting point.

The amount of spacing between the individual letters in a word will be roughly the same for the whole of that word, bearing in mind that there will be differing letter spaces between some sets of letters. The overall effect should be of an even flow of spacing throughout the word.

Word spacing is a bit easier to judge. With capitals you should allow a space equal to the width of a letter O between each word. For lower case letters allow a space equal to the width of the letter n. It would, for example, be wrong to start a line of text using black letter and giving a very wide space between the first two letters. This would change the overall style of the face completely.

Opposite page top:
The spacing is least between two rounded letters, and greatest between two upright letters. Word spacing should approximate to the width of a letter 'o'.

Opposite page below:
Lovely flowing italic interpretation of a Chinese proverb. (Melvin Stone)

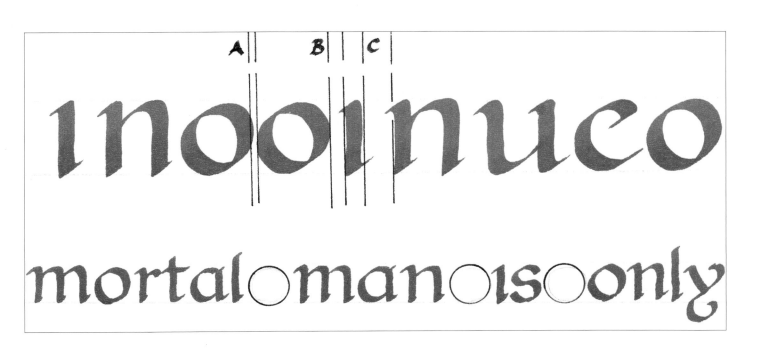

If there be righteousness in the heart,
there will be beauty in the character;
If there is beauty in the character,
there will be harmony in the home;
If there is harmony in the home,
there will be order in the nation;
When there is order in each nation,
there will be peace in the world.

-old chinese proverb.

Basic
Pen Strokes

O ne of the best ways of getting to know how to make letter shapes is to bind together two pencils. This will give you two points that will correspond to the two sides of each letter stroke. The two pencils need not be very long, just enough to be manageable, and you will need to cut away one side of each pencil slightly, so that they can be fitted together side by side. Bind the pencils together with tape.

Below:
Artists have always been fascinated by the 'mathematical' interpretation of lettering

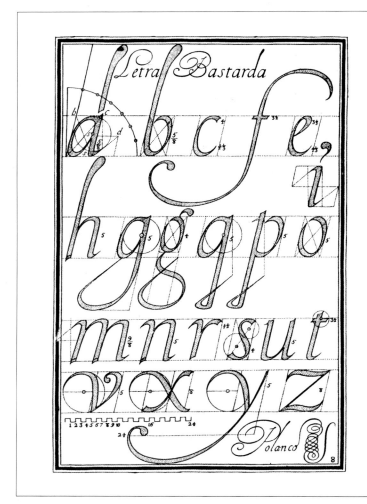

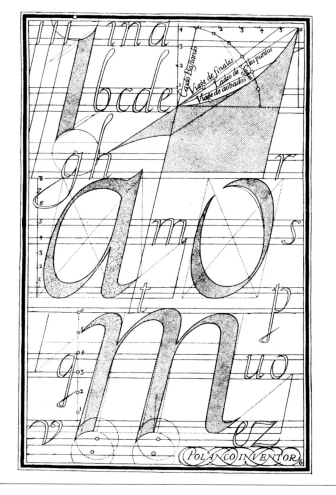

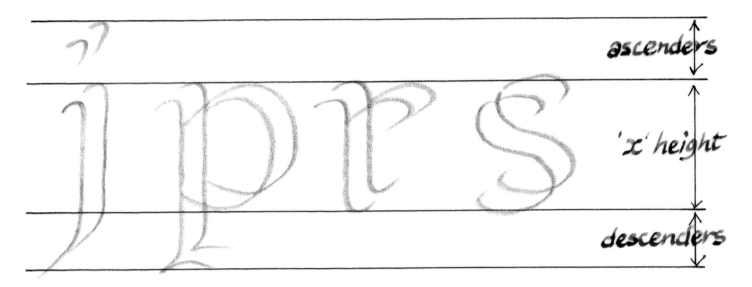

Draw two horizontal lines across a sheet of paper, the same distance apart as those illustrated on the following two pages.

Begin by aligning the two pencil points at about 30 degrees from the horizontal. This will correspond to the most common angle at which you will later make your pen strokes. Maintain the same 30 degree angle throughout the exercise. Copy the examples for simple diagonal and vertical lines, always remembering to pull the pencils rather more than pushing them in any direction.

After practising with straight lines, try a few curves.

This may sound very basic indeed, but you will soon be able to appreciate that you are forming letter shapes, and you will begin to learn how to control the writing instrument. Now try the same exercise with a pen, choosing a fairly wide nib.

If you find that your work is becoming a little cramped, try drawing a couple more lines that are a little wider apart, and do the same exercise

Using a 'double' pencil for practising Foundational letterforms.

Allow 5 double pencil widths

Allow 5 pen widths

Allow 5 double pencil widths

using a chisel-edged fibre-tip pen. The angle and the method will be the same, but you might find it easier at the slightly larger size. Later, you can come back to a nib of a more conventional size.

Letter Construction

Using the foundational hand alphabet (see page 112), start by writing the simplest strokes of the alphabet – that is, those that contain simple down strokes – h, i, l, m, n, r and u.

Next, take the round letters, which are based on the o – b, c, d, e, o, p and q.

Now you should tackle the rest of the letters of the alphabet, because they are a continuation of the basic forms you have done already.

Perhaps the hardest thing to do, at this stage, is to maintain the correct pen angle, but it is essential for calligraphy work. Like many skills, however, it will become more natural the more writing you do.

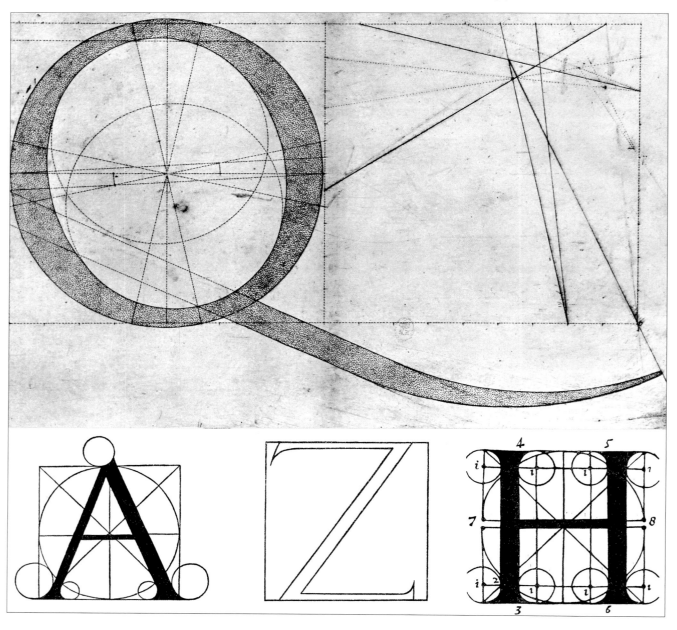

Basic Letterforms

Before giving examples of the main lettering alphabets for the calligrapher, it is essential, particularly for the beginner, to understand the basic construction of letters and the terminology. The design of the original Roman alphabet is now the basis for all present-day alphabets in the western world. Although there is no rigid terminology that applies to all the individual parts of all the letters in the alphabet, there are certain, important common expressions. For instance, a cross-stroke or bar is a horizontal stroke, such as the centre stroke of a capital A and the middle stroke of the lower case e. A stroke of the pen joins two sections together. The ascender is a stroke that rises above the main section of the letter, as in the case of the top section of the lower case forms of h, b, k and d.

The following illustration shows the main, basic definitions of letterform. In any of the different calligraphic alphabets the character of the alphabet

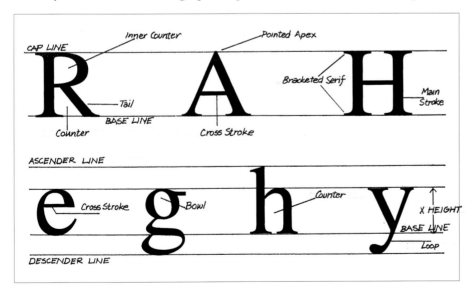

is most clearly seen in the letter O. The shape and construction of this letter sets the style for the whole of the rest of the alphabet. The horizontal shape in the uncial hand, the circular design in the Roman alphabet and the slab-like rectangular form in the black letter alphabet immediately show the overall character of that letterform.

Capitals letters (majuscules) are letters of a constant height between the base line and the cap(ital) line throughout the entire alphabet. There are slight variations to this, most obviously in the case of the Q and the J, and other minor differences when the apex of a letter rises above the cap line and when the curve of a letter falls fractionally below the base line. For the beginner, however, it is only necessary to accept that all capital letters are of a common height.

Lower case letters (minuscules) have a common basic height for the letter but with ascending and descending strokes for various letters rising above or below the base line and top of the x-height. Lower case letters share the same base line as capital letters.

The terms upper case, for capitals, and lower case, for smaller letters, come from printing and typesetting. The metal type for all characters in an alphabet used to be kept in wooden cases in the composing room. The typesetter would find capital letters contained in the higher of the two cases (the upper case) and the smaller letters in the lower case.

The next important factors are the actual height and proportion of the alphabet. For instance, how far apart should the two lines of the cap-height and base line be drawn? Although the distances will vary from one alphabet to another, the basic principle is the same as in the Roman alphabet. When these proportions are understood, all the subsequent alphabet styles will be seen to be based on, or more properly related to, the original Roman style. In the Roman alphabet the distance between the two lines was determined by the width of the stroke of the pen. The height of each letter would be approximately ten times the width of the pen stroke. If you want to experiment with this, try forming the letter an incorrect size. Make the height six times the width of the letter stroke and you will see that the capital will then look very different from the intended classical letter.

In the following sections there are examples of Roman capitals (serif and sans-serif), Rustic capitals, Uncial, Black letter, Italic, Versals and a Foundational hand. Each of these alphabets has been drawn with the pen , and each demonstrates the basic construction of all the letters of the alphabet.

Imperial Roman capitals from the Trajan Column.

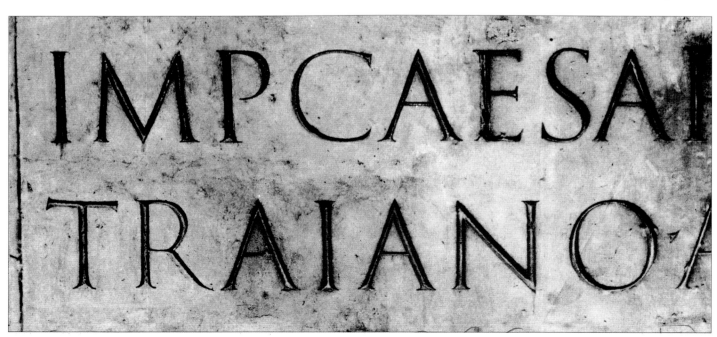

'Crows'. An exhibition work by Lisa Scattergood using a variety of nibs, including mapping pen and reed.

Part 3

Alphabet Examples
Ornaments, Gilding
& Flourishes

Calligraphy

Roman

The majority of the surviving examples of Roman lettering are inscriptional, and are found on monuments such as Trajan's Column and in the Forum in Rome. They show elegant, square capitals, which were cut with a chisel following the lines of a previously brush-drawn letter. These magnificent Imperial capitals were the basis for most of our present-day western alphabets.

As we have seen, the alphabet developed by the Romans was copied from the Greeks. The Roman alphabet was composed entirely of capitals, called majuscules. The Romans used thirteen characters from the Greek alphabet – A, B, E, H, I, K, M, N, O, T, X, Y and Z; they changed a few others, such as C, D, G, L, P, R and S; and they reintroduced others which the Greeks had dropped, F, Q and V.

The geometric principles behind the letterforms of Imperial capitals gave all the letters an imposing harmony. It is, however, very difficult to copy accurately the original style of the serifed alphabet with a pen rather than a brush or chisel. The following example, therefore, is based on Imperial capitals, but adapted for the use of a broad-edged pen.

Right:
Early chisel-cut Greek inscription work.

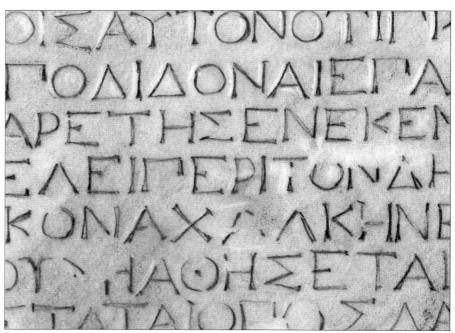

Facing page:
Classical Roman Imperial capitals.

ABCD
EFGI
LMNO
PQRS
TVX

A B C D E

F G H I J

K L M N O

P Q R S T

U V

W X Y Z

SERIF ROMAN CAPITALS

Capital height 7 nib widths; **Nib angle** 30 degrees: **Letter angle** vertical
Arrows show the sequence and direction of pen strokes

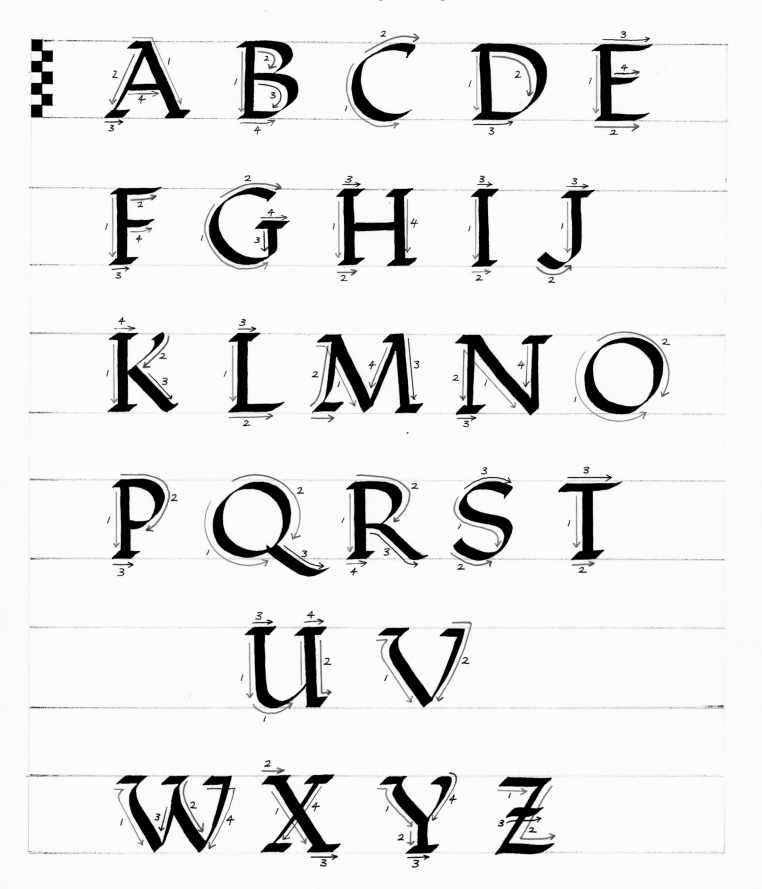

Design T+J.

reduced size

Blank.
Space to write
names (italic)

Tamsin
to
Jonathan Steer

centred

Mr and Mrs W. McNiel

request the company of

at the Church of St Paul's Holme

at 2p.m on Saturday 7th May 1996

for the Wedding of their daughter

Tamsin

to Jonathan David Steer

R.S.V.P.

The Old Mill. Armfield. Holme, Dorset G13 0H4

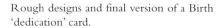

𝔉

Mr and Mrs W. McNiel
request the company of

at the Church of St Paul's, Holme
at 2p.m. on Saturday 7th July. 1995
for the Wedding of their daughter
Tamsin

to Jonathan David Steer

R.S.V.P.

The Old Mill, Armfield, Holme, Dorset. gw2 440

A B C D E F

G H I J K L

M N O P Q

R S T U V

W X Y Z

ROMAN SANS SERIF

'Sans serif' means without serifs, and this face is particularly suitable for the beginner. Because there are no serifs, it has a very simple letterform with very few complicated pen movements. However, the direct nature of the letters and the need for accurate proportioning mean that any mistakes that are made are more noticeable than on other letter faces.

Capital Height 7 nib widths; **Nib angle** 30 degrees; **Letter angle** vertical
Arrows show the sequence and direction of pen strokes

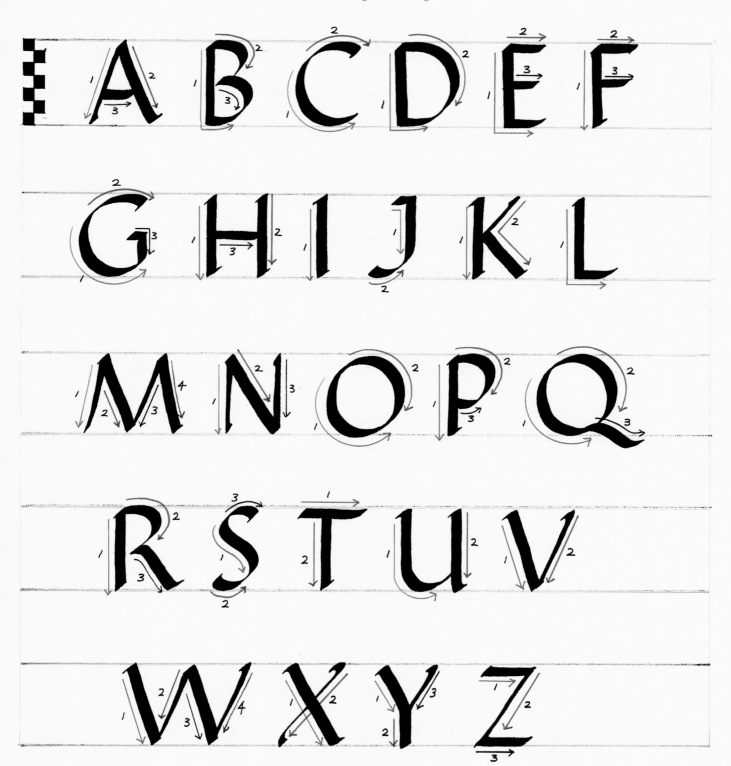

A B C D E F G

H I J K L M N

O P Q R S T U

V W X Y Z

RUSTIC CAPITALS

There was also a more informal, cursive form of the Roman alphabet, which was used as a book hand for manuscripts and documents. Rustic capitals were produced with the reed pen and the brush, and they were often used together with Roman majuscules for both writing and carving. Rustic was a more compressed but free-flowing version of the Roman capitals. It was used occasionally as a carved face, but more often as a written hand. It is well worth trying to reproduce this hand using a broad-edged brush rather than a pen, because this was the way in which it was written originally. Using a brush also gives a greater subtlety to some of the strokes.

Capital height 9 nib widths; **Nib angle** variable; 80 degrees for thin, vertical strokes; 45 degrees for diagonal stokes; **Letter angle** vertical

Arrows show the sequence and direction of pen strokes

SAEPE STYLUM V
QUAE DIGNA LEG
NEQUE TE UT M
LABORES·CONTEN

YOU MUST OFTEN TURN YOUR
ANYTHING WORTHY OF BEING R
YOU LABOUR TO BE ADMIRED
CONTENT WITH FEW READERS

RTAS ITERUM

SINT SCRIPTURUS:

RETUR TURBA

US PAUCIA LECTORIBUS

STYLUS IF YOU MEAN TO WRITE

AD A SECOND TIME: NOR SHOULD

BY THE MULTITUDE BUT BE

HORACE

Uncials

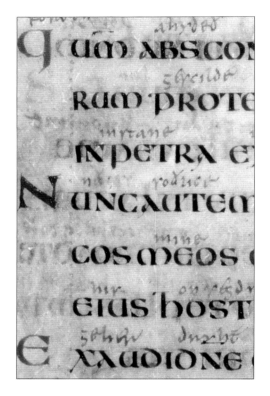

A section of the uncial script from the Vespasian Psalter, see pages 12/13

Facing page:
A beautiful example of a modern styling of uncial lettering (Melvin Stone)

Uncials - more accurately referred to as Roman uncials - were first developed during the third and fourth centuries AD. The letterforms were far easier to write than the more formal "square" Roman capitals and more legible than the rustic capitals. They became a common form of writing for official documents and the standard book hand in all early Christian writings. The letterform was very similar to earlier Greek letter styles.

The letters were upright and well rounded and made up of very simple strokes, which enabled the scribe to work swiftly. All the characters throughout the alphabet were of the same height with only very short ascenders and descenders showing. There was no distinction, as yet, between capital letters and smaller letters.

Uncials are an ideal hand for the beginner as it is a simple pen letter alphabet, written with a straight pen.

Half-uncials

Half-uncials were a style that developed naturally from uncials. They were a smaller form of the letters of the uncial alphabet, and some of the characters had more definite ascending and descending strokes. They were often used on less important documents and as a means of producing text rapidly.

It was the introduction of these smaller letters (minuscules) that marked the beginning of the distinction between capitals and lower case characters - majuscule and minuscule.

From about the fifth century numerous letter styles were developing throughout Europe. One of the most familiar styles was the beautiful work produced in the monasteries of Britain and Ireland. This was based on the Roman half-uncial lettering style was known under the collective name of insular script.

In AD 789 the Emperor Charlemagne decreed that there should be a standardization of the book hands used for all church books throughout Europe and the Roman Church. He invited Alcuin of York to his court at Aachen, and Alcuin revised all the known minuscule scripts and created a new script style now referred to as Carolingian minuscule.

In addition to the introduction of this new letter style, changes were also made to the actual arrangement of the lettering throughout a manuscript. Titling was to be done in Roman capitals and the main text of the document in the new Carolingian minuscule. Other, secondary headings were in uncials and half-uncials.

Out of the marsh and vegetation came a great culture and

MANY KINGSHIPS BORN FROM DIVINE ANCESTRY. BECAME GOD ON EARTH KING. WARRIOR PHARAOH RAMSES THE GREAT: LORD OF THE LANDS NORTH AND SOUTH.

The sovereigns Pectoral is decorated with the 'Wedget'-eye, a sacred symbol of the sun and moon, the vulture and cobra, whose perpetual reappearance evokes eternity, and are also goddess of the south and north and defends and protects the wedget-eye which is to help rebirth.

The elongated royal cartouche, rim of blue and gold which inscribes the Pharaoh's name in hieroglyphics - Ramses - and out of this eternal life and power of the gods, Kings and peoples of the Nile valley emerged an historic moment of time.

His massive army of the New Kingdom had military training with chariots, marine and infantry divisions who conquered a Libyan invasion and many attacks from the Sea Peoples of the Mediterranean. These events were recorded upon the walls of the Tombs and Great Pyramids, showing magical power, cult worship, great legends, and mythology.

The hieroglyphics or Pyramid writings are purely pictoral signs using objects of every day life, symbols of Priest and majesty, with sacred magical meaning pictograms of the most expressive line writings ever designed, and the 'Birth of the Alphabet' followed.

Wearing one of the most elaborate official crown with golden sun dials of 'Re' the sun god, which gave the King sway over all the domains of the sun, the beautiful diadem of feathered plumes and sacred objects, the age old insignia of royalty. The 'nesmet' of blue and gold, displays the outstretched wings of 'Re' as in majestic flight rests upon the magnificent collar of gold, precious stones and glass paste, exquisite design of the goldsmiths art.

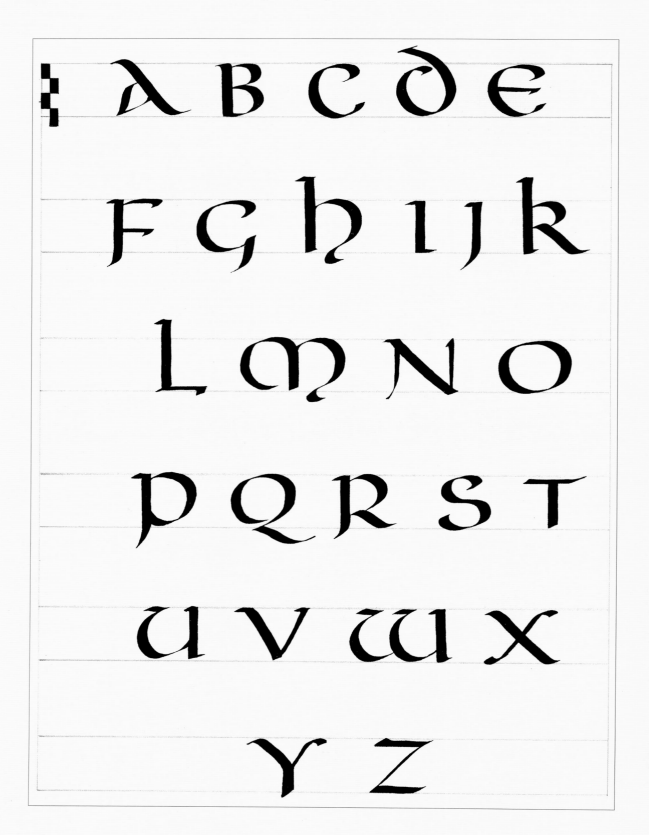

UNCIALS

Capital height 3 $\frac{1}{2}$ nib widths; **Nib angle** 15–20 degrees; **Letter angle** vertical

Arrows show sequence and direction of pen strokes

A B C D E

F G H I J K

L M N O

P Q R S T

U V W X

Y Z

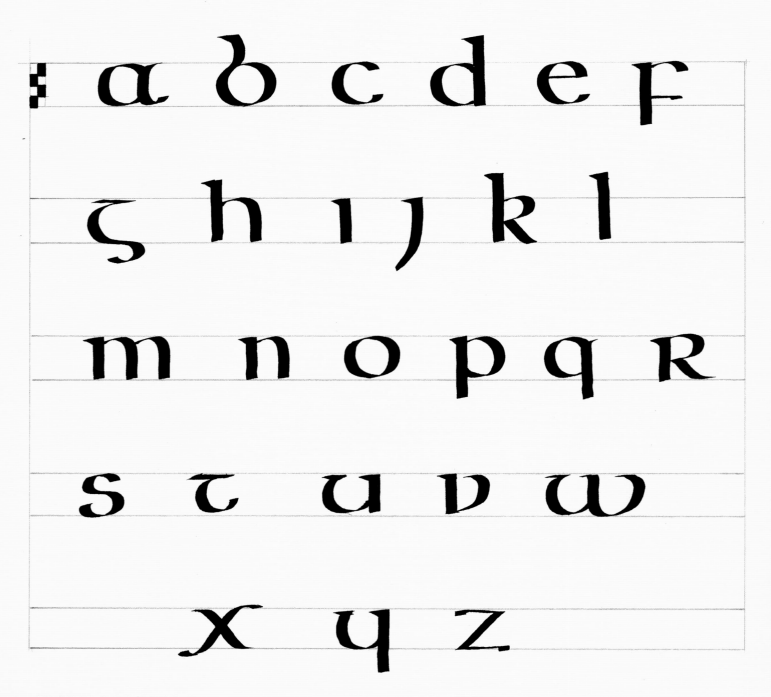

HALF-UNCIALS

Capital height 4 nib widths; **Nib angle** 15–20 degrees; **Letter angle** vertical

Arrows show sequence and direction of pen strokes

a b c d e f

g h i j k l

m n o p q r

s t u v w

x y z

Gothic Black Letter

Black letter has, as Edward Johnston put it "a halo of romance" about it. It is particularly synonymous with the age of chivalry, heraldry and the title sequences for any film based on tales of the court of King Arthur or the Middle Ages.

The term "Black letter" is often used as a collective name for the Gothic style of lettering, which was developed in about the twelfth and thirteenth centuries. The name Black letter refers not so much to the colour of the ink used, but to the overall appearance and density of the text on the written page. Manuscripts composed of a lot of lines written in Black letter had an effect that was rather like dark woven material. The earlier forms of Black letter were called Textura because of this overall patterning of letters.

In Black letter the characters were narrower than the previous uncial round hand, with thick down strokes, very fine obliques and far less space between each of the down strokes and between individual letters.

It is probably true that one of the main reason for the development of Black letter was that text could be written more quickly. If this is done, particularly with an angled pen, it is quite natural that the more considered, curved style of the previous uncial lettering became simplified to the more angular black letterform.

Black lettter was used as the main written hand when official religious documents were prepared. A cursive, more common form of Black letter, called Batard, was then used as the standard book hand of the thirteenth to fifteenth centuries. Black letter, or Textura, was also one of the letter styles that was used as a design for a printing typeface.

Black letter is a very picturesque style of lettering, but it can be rather illegible for a lot of forms of text. A manuscript composed entirely of Black letter is extremely difficult to read for any length of time. It does, however, save space. Far more text can be contained on a manuscript using black letter than if one uses the former round-handed uncial.

It is probably best to stick to using Black letter mainly for its decorative style, rather than for any lengthy passages of text.

Facing page:
A full alphabet of Textura Quadrata from the late 14th century

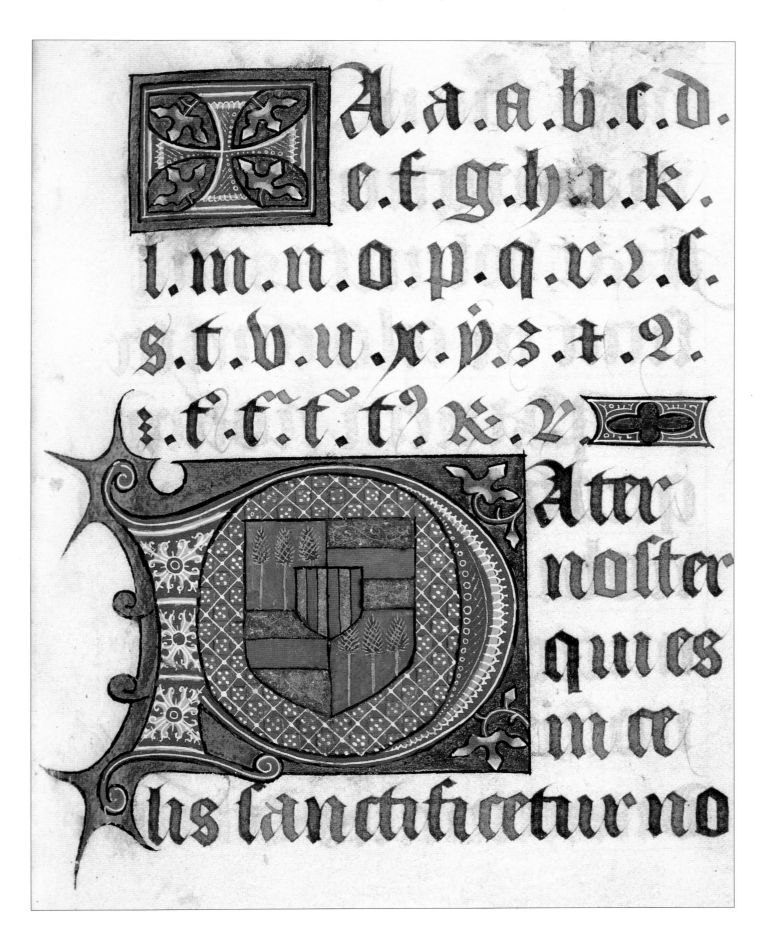

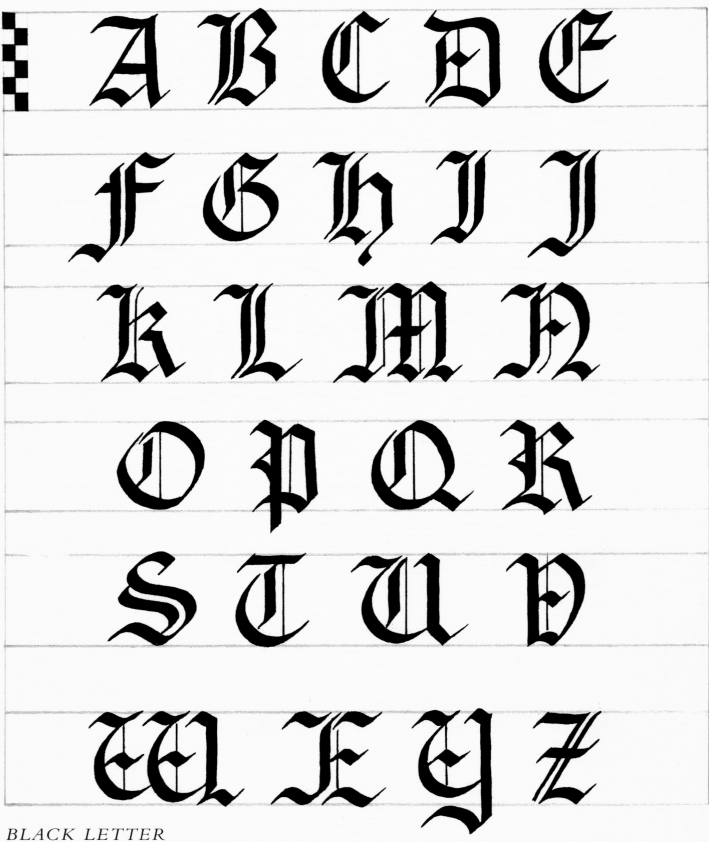

BLACK LETTER

Capital height 6 nib widths; **x–height** 5 nib widths; **Nib angle** 40 degrees; **Letter angle** vertical

Arrows show the sequence and direction of pen strokes

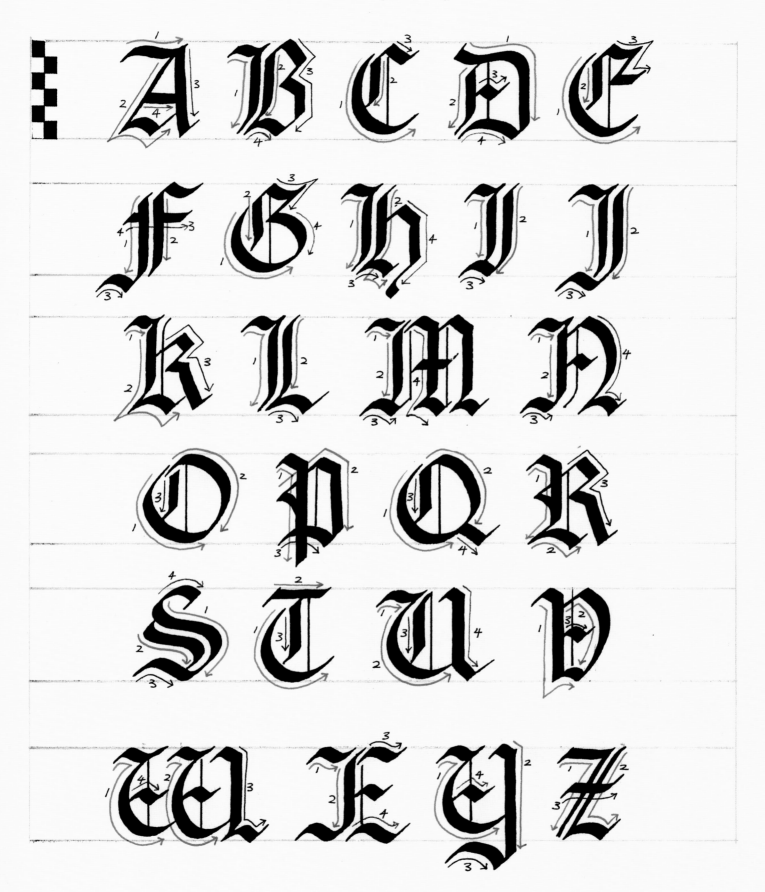

a b c d e f

g h i j k l

m n o p q

r s t u v

w x y z

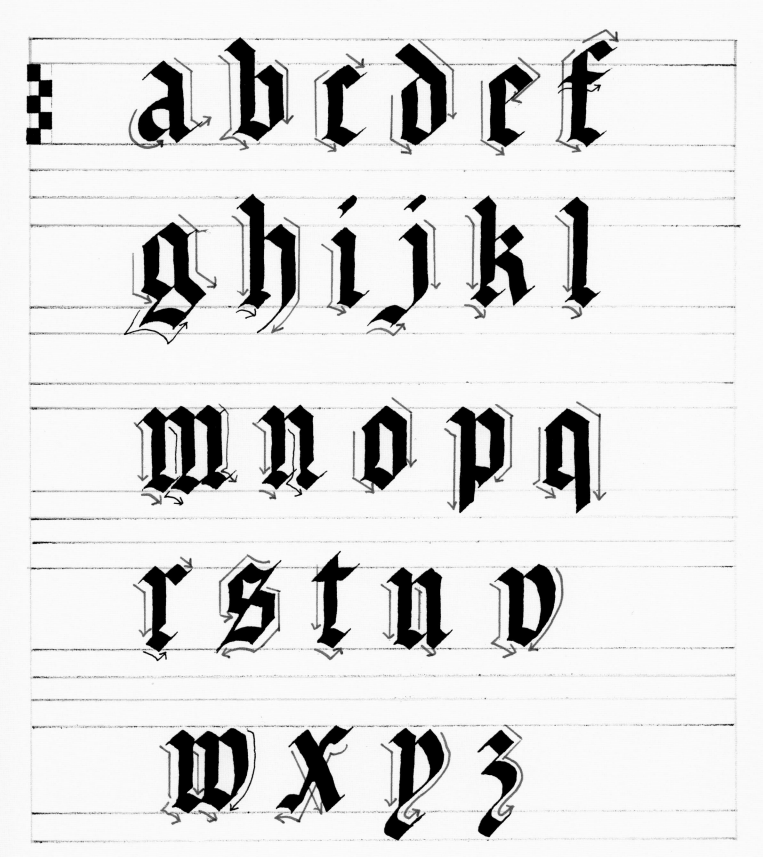

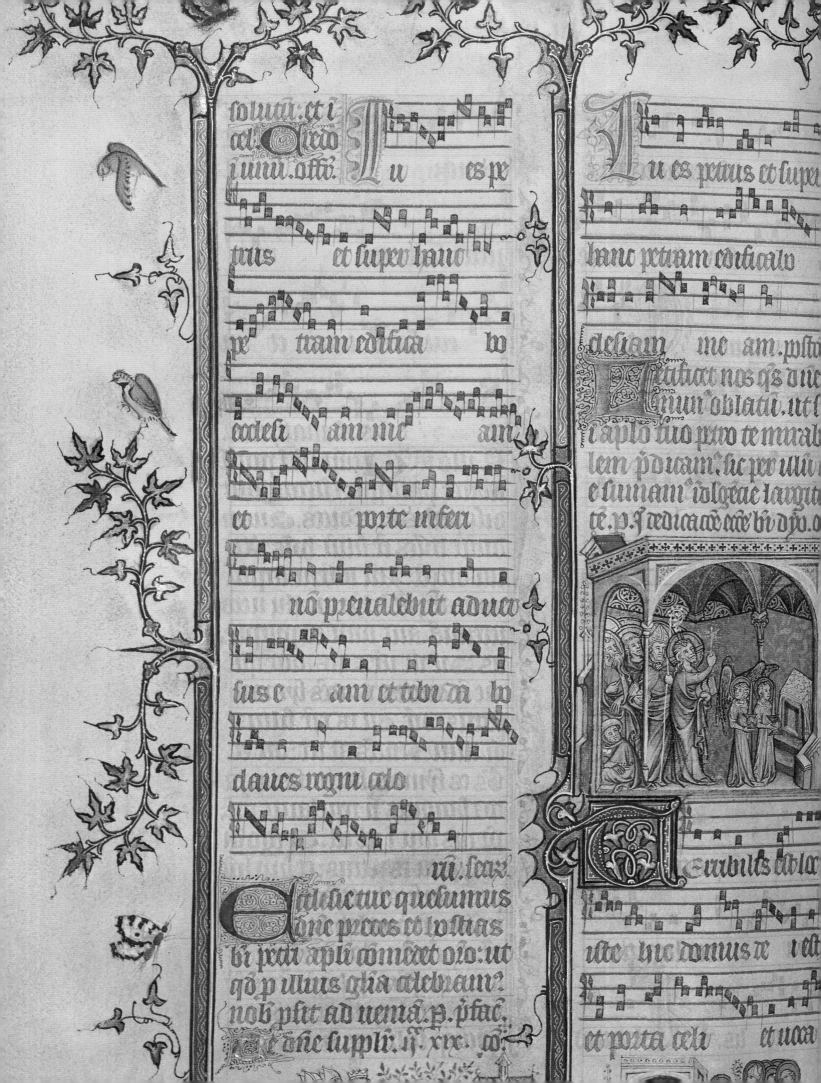

Italic

Following the Gothic style of script, the next important calligraphic style was Humanist. During the Renaissance in art and learning that occurred in the fifteenth century, Italian artists took their inspiration from the Carolingian hand and created the Humanist style. This was a more rounded letterform than the upright, angular Gothic black letter. At about the same time, there also developed a cursive style of lettering that was similar to Humanist - italic. Whereas Humanist was an upright and carefully constructed letter face, however, italic was designed not only for elegance but, more particularly, for speed. When writing quickly there is a tendency for the letters to lean towards the right. Letters become more connected and are joined with diagonal strokes.

Following pages:
A very pleasing and imaginative interpretation of textual matter. (Melvin Stone)

Italique hande

t is the part of a yonge man to reuerence his elders, and of suche to choose out the beste and moste commended whose counsayle and auctoritie hee maye leane vnto: For the vnskilfulnesse of tender yeares must by old mens experience, be ordered & gouern.

A. B. C. D. E. F. G. H. I. K. L. M. N. O. P. Q. R. S. T. V. X. Y. Z.

.D

The Lord is my pilot; I shall not
He lighteth me across dark
He steereth me in deep chann
He keepeth my log;
He guideth me by the star of holine
Yea, though I sail amid the th
I shall dread no danger, for
Thy love and thy care they sh
Thou preparest a harbour befo
Thou anointest the waves w
Surely sunlight and starlight s
And I will rest in the port of m

ift.

aters,
;

for his name's sake.

nders and tempests of life

ou art with me,

er me.

me in the homeland of eternity.

h oil, my ship rideth calmly.

ull favour me on the voyage I take;

God for ever.

The italic letterform is a beautiful face and very well suited to the beginner. It is a fluid hand, and each letter requires fewer strokes to complete each letter than were required for a number of earlier letterforms. Ascenders and descenders are more pronounced and flowing. The capital letters are a slanted form of the original Roman majuscule capitals.

The italic hand version illustrated here is taken from the alphabet especially developed early in the 1900s when calligraphers were trying to get away from the copperplate hand of the nineteenth century. It follows the same basic style as the original Italian italic.

Printing from moveable type was introduced in the fifteenth century. This greatly affected the need for calligraphy, and although it did not entirely kill it off, there was a need for an even more flowing and quickly written hand. Letterforms were, therefore, simplified and made with a greater number of continuous, linking strokes. Italic continued to be used through to the seventeenth century in several basically similar forms and eventually led on to the style known as copperplate.

Copperplate alphabet style sheet by George Bickham, 1773

This, then, became the main book hand up to, and into, the twentieth century, particularly for official documents. It is, unfortunately, a very precise and difficult hand for the beginner.

Use a square pen, which should be held at an angle of about 40 degrees to the writing line. Letters are sloped slightly to the right, and letterforms are not as rounded as previous round hand styles. The overall effect is angular and free-flowing.

Italic lends itself to dramatic ascenders and descenders, but you should be careful not to make the work illegible by using too many flourishes. Care should be taken with line spacing.

Facing page:
'Tiger, Tiger'. Specially commissioned work by Lisa Scattergood. Lettering done in several nib widths to achieve a 'diminishing' effect towards the embossed centrepiece

Tiger Tiger burning bright In the forests of the night; 492

What immortal hand or eye could frame thy fearful

symmetry? In what distant deeps or skies Burnt the

fire of thine eyes? On what wings dare he aspire? What

the hand dare seize the fire? And what shoulder, and what art,

Could twist the sinews of thy heart? And when thy heart beg

What the anval? what dread grasp Dare its deadly terrors grasp,

When the stars threw down their spears And water'd heaven

made the lamb make thee? Tiger Tiger burning bright. 1757 .1827

with their tears Did he smile his work to see? Did he who

an to beat. What dread hand? and what dread feet? What the

hammer? What the chain? In what furnace was thy brain.

William Blake

A B C D E F

G H I J K L

M N O P Q

R S T U V

W X Y Z

ITALIC

Capital Height 8 nib widths; **x-height** 6 nib widths; **Nib angle** 30 degrees; **Letter angle:** 5 degrees

Calligraphy

A B C D E F

G H I J K L

M N O P Q

R S T U V

W X Y Z

a b c d e f g

h i j k l m n

o p q r s t u

v w x y z

a b c d e f g

h i j k l m n

o p q r s t u

v w x y z

A demonstration of the progress from rough idea through to finished design. The artist wished to send a very individual card to celebrate the birth of a friends' second child. Rather than relying on available commercial cards the artist created this delightfully simple design based upon the full names of the baby and the date of birth. The actual style of calligraphy (in this case a version of the Foundation hand) was decided upon. The wording was then 'roughed-out' using a chisel edged carpenters, or layout, pencil on to ordinary paper. Various arrangements, based upon a square and a circular layout were tried. Having decided on a circular motif the lettering was then traced through onto a compass-drawn circle and adjustments made to ensure that all lettering fitted the central axis. This rough lettering was then lightly traced on to the final card. Lettering was done with a square cut metal pen using Cobalt Blue Gouache paint. Further decoration and flourishes were added to the inner area. The fine vertical lines within the capital letters were drawn with the edge of the pen.

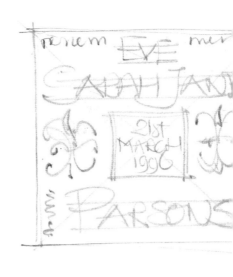

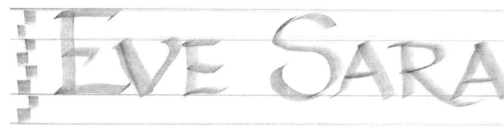

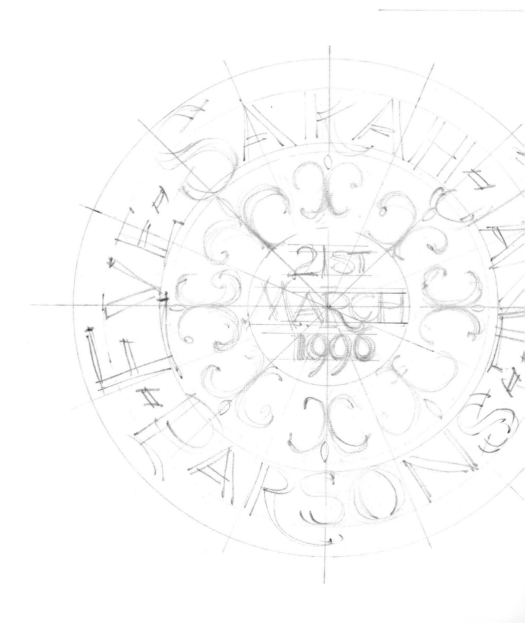

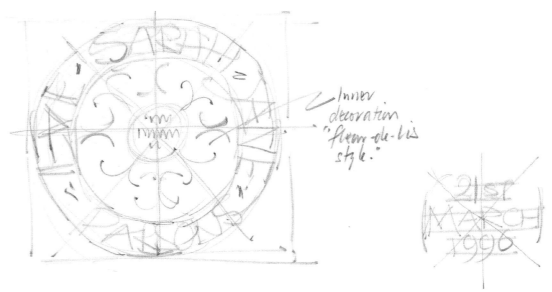

Inner
decoration
"fleur-de-lis
style."

21ST
MARCH
1996

JANE PARSONS

·EVE·SARAH·JANE·S·PARSONS·

21ST
MARCH
1996

SWASH
ITALIC

Capital Height 8 nib widths;
x-height 6 nib widths;
Nib angle 40 degrees;
Letter angle about 5 degrees

Arrows show sequence and
direction of pen strokes

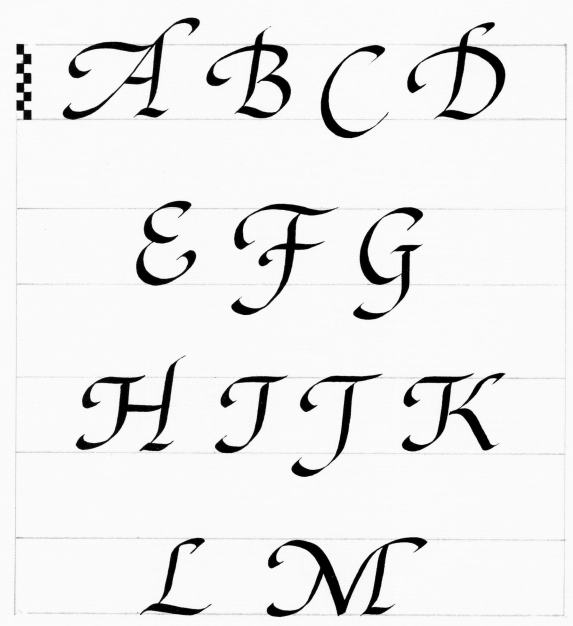

N O P Q

R S T U

V W X

Y Z

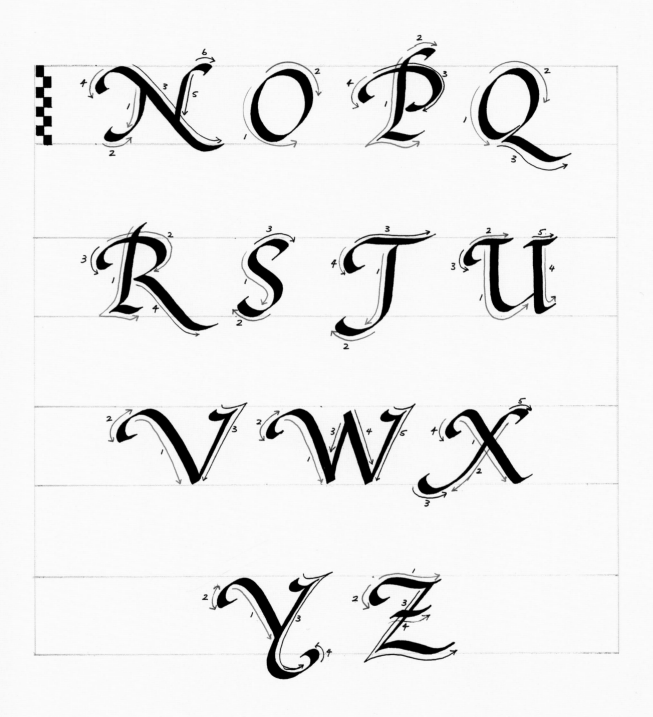

a b c d e f g

h i j k l m n

o p q r s t u

v w x y z

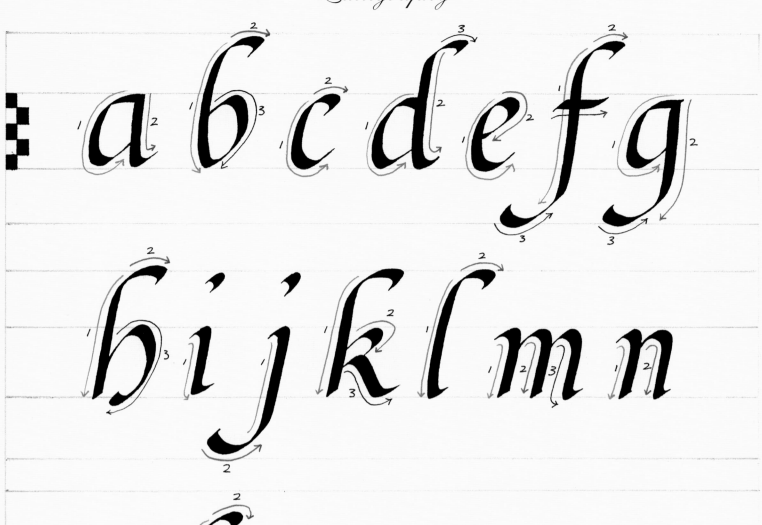

Versals

Versals were built-up letters and a form of ornamentation that was often used to highlight particular sections of text or, more appropriately, verses. Versals were also used to form a single line of introductory text, but are more often to be seen in old manuscripts as single, ornamented and illuminated letters, used to draw attention to passages of text.

The main character of versals is that they were made up of a number of different strokes using a brush or a pen with a fairly narrow nib. This is unlike previous letterforms, which were often written with a broader pen in single strokes.

Versals lent themselves to decoration. The enclosed bowl of the letters D, Q, O, G, M, N, P and R are frequently found in manuscripts containing elaborate decoration and illumination.

The simplest form of the versal capital is made with a pair of down strokes with a space between. If you intend to use the versal as a decorated initial this space is then filled with black ink or with colour. The cross strokes of letters such as E, F, L, T and Z are wedge-like and drawn with a slight curve toward the outer ends.

Versals can be used as decorated initials with most other alphabet styles, but they are particularly suitable for use with the uncial and Roman letter styles.

The writing of versals differs slightly from that for other alphabets. The pen is held in a slightly more upright position. The board is lower than normal, and the nib needs to be narrower than the one that has been used for the rest of the text. The narrower nib will help in the construction of the wedged serifs.

u es petrus et super

hanc petram edificabo ec

cleciam me am. psm̄.

Sātificet nos qs dn̄e?
munuſ oblatũ. ut ſic
ī aplo tuo petro te mirabi
lem p̄dicem̄? ſic per illuſ tu
e ſunam̄ ī dulgeāe largita
te. p. y. J dedicacōe eccē̄ bⁱ d’w. off

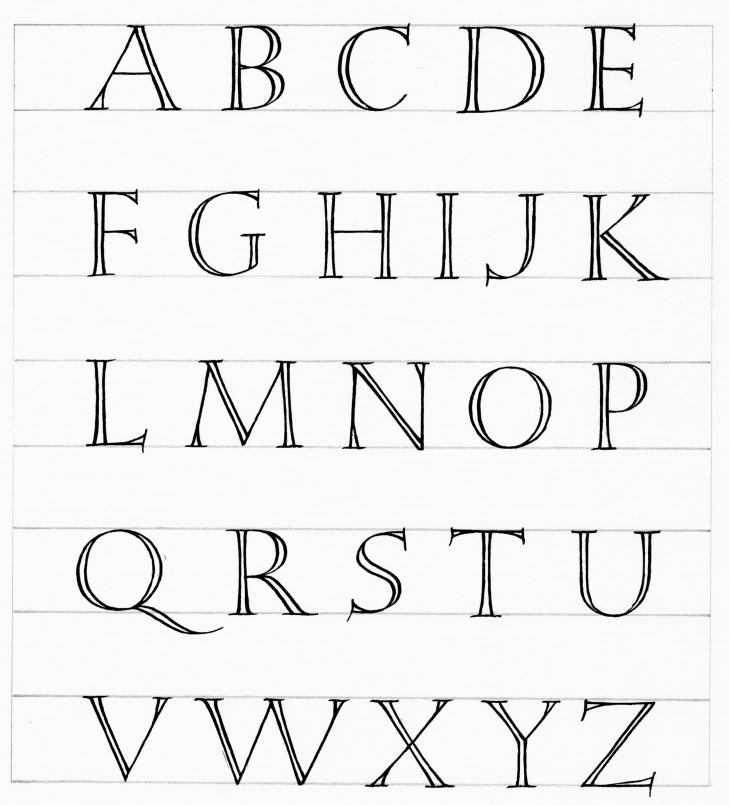

VERSALS

Capital height 8 pen widths; **Nib angle** variable between horizontal and 80°

Arrows show sequence and direction of pen strokes

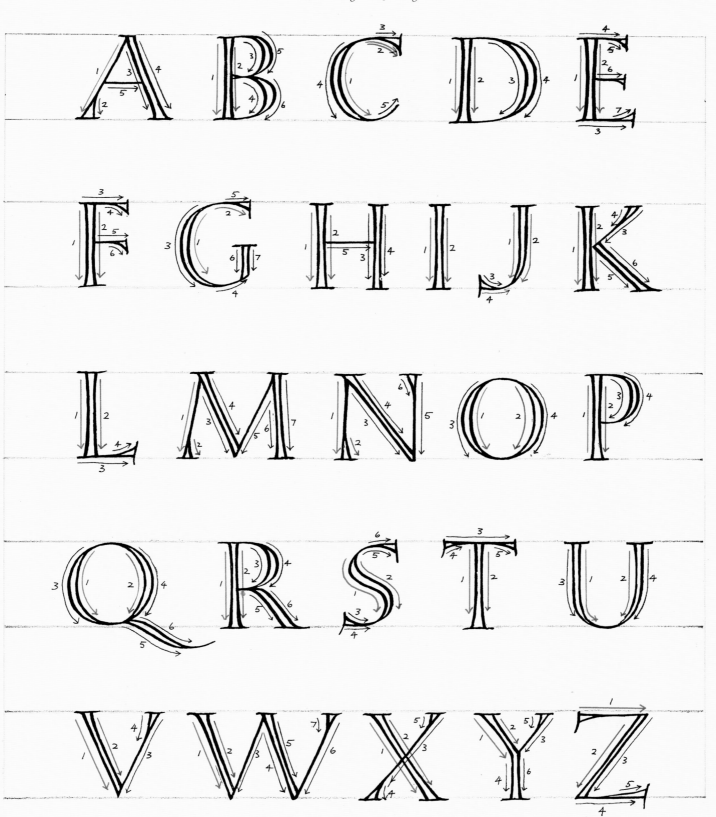

ABCDE
FGHIJK
LMNOP
QRSTU
VWXYZ

LOMBARDIC INITIALS

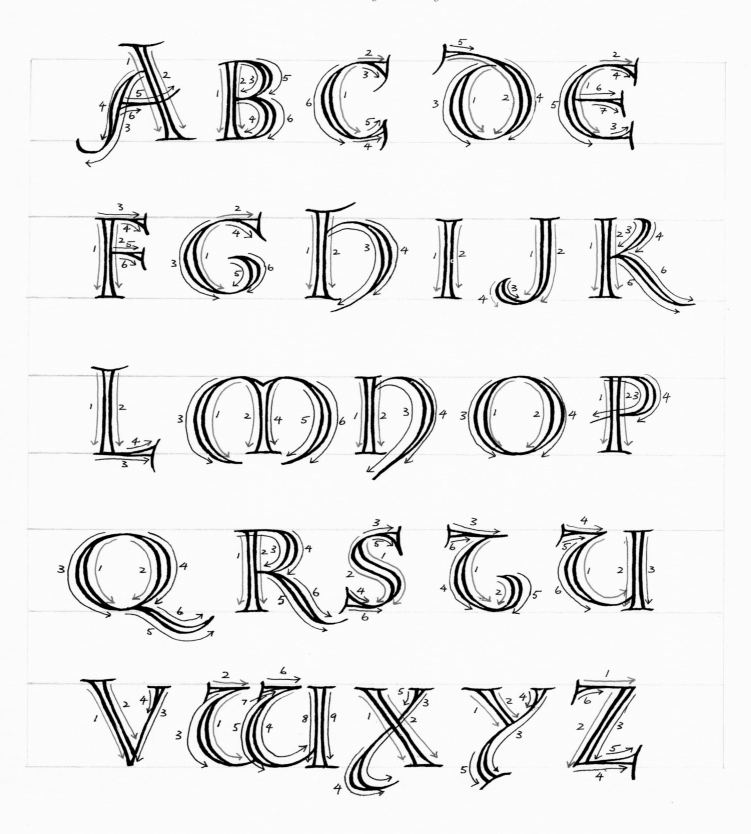

Following pages:
Double page spread from a modern manuscript
by Hazel Dolby

◇ OH HYRE LUD · IN HER LANGUAGE ◇ ICH LIBBE · I LIVE ◇ SEMLOKEST · SEEMLIEST ◇
LYHT · ALIGHTED

BYTUENE MERSHE AND AVERIL
WHEN SPRAY BIGINNETH TO SPRINGE
THE LUTEL FOUL HATH HIRE WYL
ON HYRE LUD TO SYNGE
ICH LIBBE IN LOVE-LONGINGE
FOR SEMLOKEST OF ALLE THYNGE
HE MAY ME BLISSE BRINGE
ICHAM IN HIRE BAUNDOUN

AN HENDY HAP ICHABBE Y-HENT
ICHOT FROM HEVENE IT IS ME SENT
FROM ALLE WYMMEN MY LOVE IS LENT
AND LYHT ON ALYSOUN

◆BAUNDOUN-THRALDOM◆HENDY-GRACIOUS◆Y-HENT-RECEIVED◆ICHOT-I WOT

Foundational Hand

Edward Johnston is credited with being the father of modern calligraphy and his influence has been enormous throughout the twentieth century. In fact, many of his students became some of the leading lettering and typographic artists of their generation.

At the end of the nineteenth century there was a revival of interest in the craft of calligraphy, and Edward Johnston became a student of William Morris. By 1906 Johnston was teaching others the crafts of traditional calligraphy, and he created his famous foundational hand for his students. He based this new design upon a tenth-century English uncial letterform, which he had studied during his researches into traditional alphabets.

The construction of the letters was very similar to the original hand, but there were simplified forms adapted for the broad-edged pen.

Johnston's foundational hand is still one of the best introductions to calligraphy for the beginner, and it is an excellent basis for exploring other hands and adapting to these to suit your own style.

The following example is based upon Johnston's foundational hand.

A Thesis
describing
toys which have
amused children
from
the Stone Age
to the
Victorian Era,
which
will appeal to
all who are young
at heart

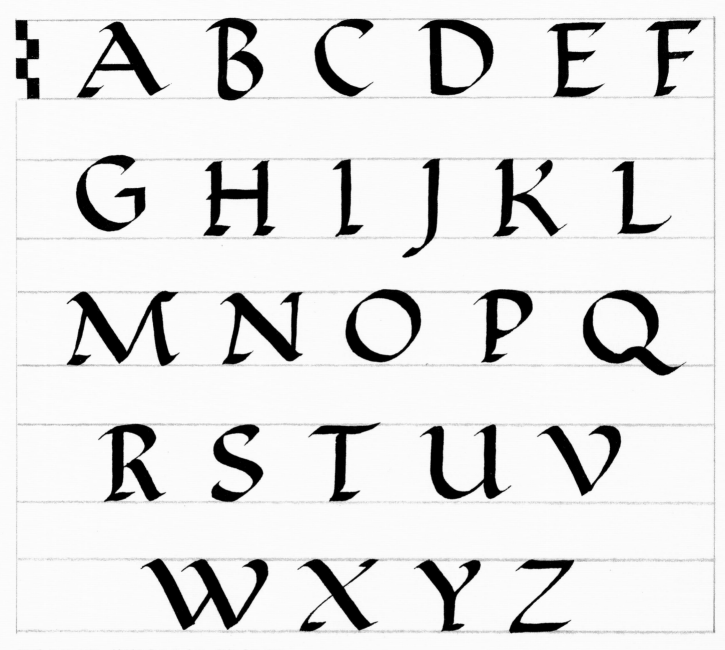

FOUNDATIONAL HAND

x-height 4 nib widths; **Ascenders and descenders** 3 nib widths; **Nib angle** 30–35 degrees; **Letter angle** vertical

Arrows show sequence and direction of pen strokes

A B C D E F

G H I J K L

M N O P Q

R S T U V

W X Y Z

abcdefg

hijklm

nopqrs

tuvw

xyz

a b c d e f g

h i j k l m

n o p q r s

t u v w

x y z

Ornaments, Gilding & Flourishes

O nce you have gained some confidence from lettering the previous alphabets and you are beginning to do your own work, it is worth spending a little time exploring the world of decoration.

You may feel that the particular work you are doing could, in some way, be a little more exciting than it is at the moment. We have already covered versals, a form of initial letter that could be placed at the beginning of a section of text and that, because of its decorative quality, would increase the interest of that item of text. You may now feel that your present text could do with a little elaboration.

Illuminated Letters

The simplest way to illuminate the text is, first, to introduce a little colour into the text area. If, for example, you are doing several lines of text on a single sheet, some of these lines could be done in red rather than black ink.

A fine example of well balanced illuminated lettering

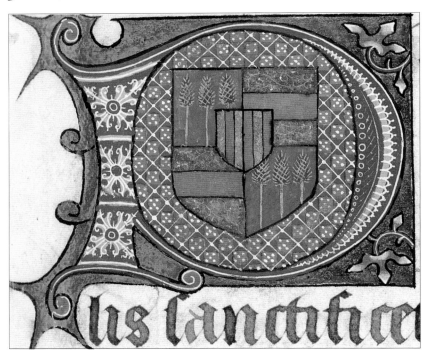

The addition of red is the very simplest form of illumination, and it was once referred to as rubricating. The style originated in old manuscripts – particularly religious documents – and was later copied in printed works by using italic text.

If you use versal capitals in order to highlight the beginning of a text, these can also be coloured. The outline sections of versal capitals can be filled in with colour, and, if you are feeling really adventurous, you can draw the complete versal letter in colour or vary the outline colour and in the infill colour. If the initial letter or versal has a bowl - for example, B, D, G. O. P, Q and R – you can use that area for adding an illustration or picture.

Gilding

Large initial letters can be gilded by the addition of either gold leaf or gold paint. The simplest way is to draw the outline of the letter first, and then paint into the space of the letter with a gouache designer's gold or other gold paint.

SURELY THERE IS A MINE FOR SILVER
And a place for gold which they refine.
Iron is taken out of the earth,
And brass is molten out of the stone
Man setteth an end to darkness,
And searcheth out to the furthest bound
The stones of thick darkness and of the shadow of death.
HE BREAKETH open a shaft away from where men sojourn;
They are forgotten of the foot that passeth by;
They hang afar from men, they swing to and fro.

AS FOR THE EARTH out of it cometh bread:
And underneath it is turned up as it were by fire.
The stones thereof are the place of sapphires,
And it hath dust of gold
THAT PATH NO BIRD OF PREY KNOWETH
Neither hath the falcon's eye seen it:
The proud beasts have not trodden it
Nor hath the fierce lion passed thereby
HE PUTTETH FORTH his hand upon the flinty rock
HE OVERTURNETH the mountains by the roots.

'Rubricated' text. A copy of a sheet originally produced by Edward Johnston

Foil-blocked text originally used for a Christmas
card. See also page 48.
(Ewan Clayton)

If you want to gild the letter, draw the outline and cover the inner area with PVA adhesive.

Leave this to dry, then warm the adhesive slightly by breathing on it or directing a hair-drier on it so that it is slightly tacky. Place a sheet of gold leaf directly on the letter, and the gold leaf will adhere to the adhesive. Burnish the area of the letter gently with a piece of silk and carefully peel away the gold leaf.

Gold leaf is expensive, but it is worth experimenting with it. In addition to simply laying it over a simple letterform as described above, it can be used to create very elaborate initial letters.

Use pencil to draw an initial letter and colour it, then use gold leaf to add decoration around it. Look at examples of medieval manuscripts for inspiration and ideas.

Flourishes

The great age of "flourishing" started during the sixteenth century with the popularity of the italic style of lettering. The most important thing to remember with flourishes is that that they should always add to the overall design of the lettering and not overpower it.

This means that it would be a mistake to add flourishes to every available letter in a piece of work. One or two beautifully executed flourishes can add enormously to the overall effect of your work.

Late 17th-century flourishing from 'The Penman's Paradise' by John Seddon

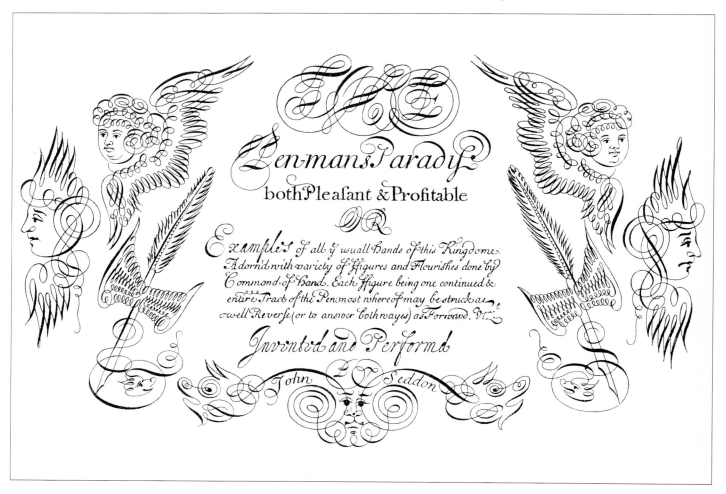

ENIGMA
The beginning of Eternity
The end of time and space
The beginning of every end
and the end of every place

There are examples of pieces of lettering that were composed almost entirely of flourishes – not just the lettering, but also the accompanying borders. For present purposes, however, it is wise to stick to something simpler, at least at first.

You can add flourishes to almost any letter style, but some faces are more suitable than others. Italic, foundational hand and black letter are particularly suitable for the addition of flourishes.

It is important that the amounts of white space in the flourish are approximately the same in order to give the flourish a uniform appearance.

Only add flourishes to letters that have parts that can be extended. This may seem an obvious consideration, but some letters do not have any natural anchors for the flourish.

Make sure that any flourishes do not conflict with the natural line spacing of the main text.

If a flourish is added to the first line of a poem and sweeps down across the second line of text, it could unbalance the rest of the text. Remember to use flourishes carefully and thoughtfully.

Calligraphy

Glossary

Arch The curve that emerges from the main stem of a lower case letter.

Artwork The finished work ready for reproduction.

Ascender That portion of a lower case letter that rises above the x-height.

Base line The line on which the x-height of the letter sits. Also known as the WRITING LINE.

Black letter A style of Gothic script constructed of heavy, narrow spaced characters.

Body height Also known as the X-HEIGHT. The depth of the main body of a lower case letter, excluding ascenders and descenders.

Book hand Script used to write text in manuscript books before the advent of printed type.

Bowl The curved stroke of a letter which encloses the space known as the COUNTER.

Built-up letters Constructed, rather than lettered characters. First outlined and then filled. As in VERSALS.

Capitals Majuscule letters which are all of the same height.

Carolingian The style of lower case letters (MINUSCULE), introduced during the eighth century.

Centred Lines of lettering arranged in a symmetrical layout.

Copperplate A very flowing italic style of script with flourishes developed from the Italic hand.

Counter The enclosed space of a letter. See also BOWL.

Crossbar or **cross stroke** A horizontal letter stroke.

Cursive A rapid, informal style of lettering.

Descender That portion of a lower case letter that falls below the BASE-LINE.

Ductus The order of strokes used to construct a letter.

Format The overall layout of a piece of work.

Gilding Gold leaf application to decorate a letter.

Gothic The heavy, angular style of writing practised in medieval times.

Gouache Opaque watercolour paint. Also known as designer's colour.

Hairline The finest pen line made to finish or decorate basic letterforms.
Hand The style of script or lettering written by hand.

Illumination Decoration using either gold leaf or colours to embellish a manuscript.
Interlace Interweaving lines forming a decorative style.
Italic A style of handwriting with the letters slanting to the right. Creating oval letterforms rather than round.

Line space The distance or spacing between the base lines.
Lower case Minuscule or small letters of an alphabet which also include the ascenders and descenders as distinct from the CAPITAL letters.

Majuscule Capital letters.
Manuscript Generally used for any handwritten document prior to the advent of printing.
Minuscule Lower case letters.

Parchment Writing material made from either goatskin or sheepskin.
Paste-up Artwork or a layout design constructed of items cut up and pasted on to paper or board.

Quill A writing instrument made from the wing or tail feathers of a swan, goose or turkey.

Reed pen A pen made from a hollow reed or cane.
Roman The formal alphabet of capital letters constructed by the Romans. Also a typographic term for any upright form of type or lettering.
Rustic An informal style of lettering based on the Roman CAPITALS.

Sans serif A term used for any lettering not having serifs.
Serif A short finishing stroke of a letter known under several terms such as wedge, club, hooked, hairline or slab.
Stem The main vertical stroke of a letter.

Tail The diagonal lower diagonal stroke of the Q and lower case y.
Textura A Latin word meaning "woven" and descriptive of a form of Gothic script with very dense, regular characters.

Uncial Latin majuscule letters. A rounded letterform with very short ascenders and descenders.
Upper case Typographical term for capital letters. See also MAJUSCULE.

Vellum Fine parchment made from the skin of lamb, calf or kid, with a smooth texture.
Versal A large, decorative letter used to open text in a paragraph or manuscript.

Weight The relationship of the width of the nib to the x-height of the text.

x-height The height of the main body of a letterform excluding the ascenders and descenders.

Index

Further Reading

The Art of Calligraphy. David Harris, Dorling Kindersley, 1995

Calligraphic Styles. Tom Gourdie, Studio Vista, 1979

The Calligrapher's Handbook. Edited by Heather Child, A&C Black, 1985

Calligraphy Masterclass. Edited by Peter Halliday, Collins, 1990

The Calligrapher's Project Book. Susanne Haines, Collins, 1987

Capitals for Calligraphy. Margaret Shepherd, Thorsons Publishing, 1981

The Craft of Calligraphy. Dorothy Mahoney, Pelham Press, 1981

Historical Scripts. Stan Knight, A&C Black, 1984

The Illuminated Manuscript. Janet Backhouse, Phaidon, 1979

Lettering Design. Michael Harvey, Bodley Head, 1975

100 Easy Calligraphy Projects. G.Roland Smith, Thorsons Publishing, 1989

Pen Lettering. Ann Camp, A&C Black, 1984

The Pratical Guide to Calligraphy. Rosemary Sassoon, Thames & Hudson, 1989

The Story of Writing. Donald Jackson, Taplinger, 1986

The Universal Penman. George Bickham, Dover Publications, 1965

Writing, Illuminating & Lettering. Edward Johnston, A&C Black, 1985

PICTURE CREDITS